HEREFORDSHIRE MURDERS AND MISDEMEANOURS

DAVID PHELPS

AMBERLEY

Dedicated to my good friend Tim Cooke

First published 2024

Amberley Publishing
The Hill, Stroud
Gloucestershire, GL5 4EP

www.amberley-books.com

British Library Cataloguing in Publication Data.
A catalogue record for this book is available from the British Library.

ISBN 978 1 3981 1775 4 (paperback)
ISBN 978 1 3981 1776 1 (ebook)

Typesetting by Hurix Digital, India.
Printed in Great Britain.

CONTENTS

INTRODUCTION

As one might expect from a county with a bloody past, Herefordshire has seen some shocking murders and appalling crimes. From the only British solicitor to be hanged for murder to the still mysterious death of an architect who had a fanatical belief that his home had been the site of King Arthur's castle, the county is the repository of some dark and fascinating stories.

From the murder of the future patron saint of Hereford Cathedral to what many people see as the murder of the River Wye due to pollution, this book will span 1,300 years of crime, whose victims and perpetrators range from kings to farm labourers.

People often ask is there such a thing as the perfect murder. My answer is probably, but such a thing does not figure here. If it is perfect, no one realizes that it was a murder. From research there seems to be three basic rules to follow: 1) Try to murder someone you don't know, or at least someone with whom the police cannot connect you. 2) Do not dismember the corpse in your own house; you'll never get rid of all the blood. 3) Do not return to the scene of the crime, join any search for the missing person or do anything that might bring you to the attention of the police.

The book does feature some almost perfect murders, where the police were unable to find a suspect. Such was the case with the disappearance of Derek Saville, where no body was ever found, so the police were not sure if it was even a case of murder. Perhaps he just wandered off, easier to do at a time without CCTV or credit cards. On the next level there are crimes where the police think they know who did it but are unable to find enough evidence to bring it to trial, such as the death of the shopkeeper in Clehonger, or unable to convince a jury that the evidence is strong enough as with the murder of Simon Dale.

The past is a different country and some crimes that in their day produced death sentences would now be more likely to lead to short prison terms, if anything.

As well as grim murders we will also cover ills that have bedeviled the county, such as the effect of slavery, details of which are only now coming to light, and social unrest caused by anger and inequality.

Above: Sometimes there is more than humans to be frightened of in the Herefordshire countryside. (David Phelps)

Right: Herefordshire sketch map.

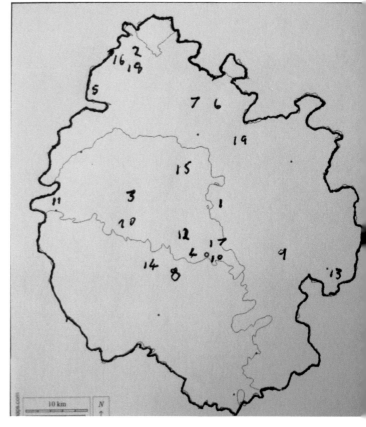

1. THE MURDER OF SAINT ETHELBERT

The end of the eighth century in England was an insecure time for everybody, even kings. Not that a political entity called England existed at that time – the country was broken up into several kingdoms of competing warlords, each forming alliances and going to war to assert their dominance.

Offa of Mercia had risen as the most powerful king on the island, someone whom others would have to take into account and placate if they were going to survive; a man with a history of being ruthless if he thought his power was being challenged.

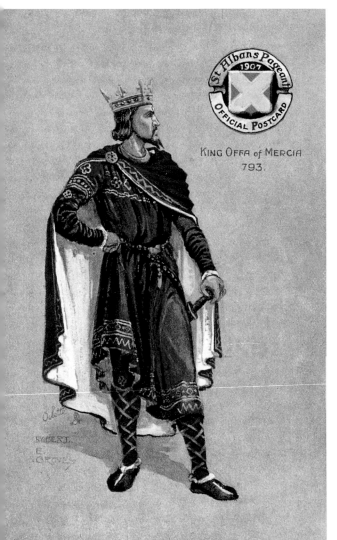

King Offa. (St Albans pageant, early twentieth century)

Meanwhile, in East Anglia, Ethelbert was king. Although historians do not like to refer to this time as the Dark Ages, documentary evidence is sparse and confusing. It may be that Ethelbert had been on the throne since 779 CE or had only recently come to the throne in 794, when our story begins.

What is in no doubt is that Ethelbert was a sub-king of Offa and had to be wary of doing anything to annoy the mightier man. He seems to have failed.

Over the last few years metal detectorists have found several coins issued by Ethelbert, which could be interpreted as a challenge to Offa's authority. Then, in 792, the great monastery at Lindisfarne was destroyed by raiders from Scandinavia and there was every indication that the attacks would be repeated. Offa needed someone he could trust guarding the eastern coast.

Somehow Ethelbert was persuaded to come to Offa's villa at Sutton Walls near Marden, though surprisingly little archaeological evidence has been found here of what must have been a substantial building. Offa's main palace was at Tamworth but Ethelbert seems not to have been suspicious of being required to travel the width of the country to see his overlord.

Birth of St Ethelbert. (Hereford Cathedral)

Once there Ethelbert was arrested and immediately beheaded, his body thrown into the marshland around Marden. Bodies dating to that time found at Sutton Walls have been interpreted as Ethelbert's unfortunate bodyguard, although some historians have suggested that they might be remnants of the Viking army that left behind the Herefordshire hoard (see below). Offa wasted no time in advancing on East Anglia and asserting his dominance.

But, even in those bloody days, murdering a king was unusual. They might die in battle, which was considered an occupational hazard, but killing one in cold blood was thought by many as beyond the pale. It did not help Offa that the Church was at the time seeking to limit the amount of bloodshed by asserting that anointed kings were directly appointed by God and were therefore sacrosanct. Offa was forced to dig up the body and have it re-buried in the new cathedral in Hereford. Where the body rested overnight a miraculous well appeared. Even worse for Offa, miracles were said to have taken place at the tomb and Ethelbert was declared a saint, becoming joint patron of the cathedral with the Virgin Mary, the pilgrims providing a useful source of income to the cathedral clergy.

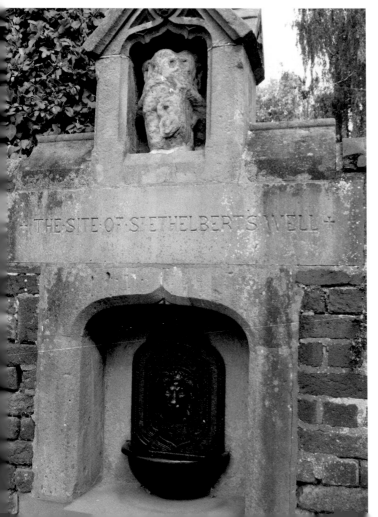

St Ethelbert's Well.
(David Phelps)

The Church still had a problem. They were accusing one king appointed by God of killing another. Their solution, set out in later chronicles, was to blame the women. The new story was that Ethelbert, blinded by love of Offa's daughter, had only come to Sutton Walls to arrange the marriage. Here he had fallen foul of Offa's jealous queen, Cynethryth, who tried to persuade Offa to kill this dangerous man. In an unusual fit of indecisiveness Offa refused, so the queen inveigled one of her own retainers to commit the murder.

While that might have satisfied the medieval mind, later historians doubt the story, not least because it mirrors quite a few lives of the saints, killed by perfidious women while the innocent menfolk looked on without involvement. Cynethryth seems to have been held in great respect by Offa, one of the first women to appear on a Saxon coin, jointly with her husband, a very high mark of honour and trust indeed.

After Offa's death, she became abbess of Cookham, which became a vibrant hub of trade and culture, a somewhat unusual honour for someone suspected of killing a king.

SAXON LADY
793

Queen Cynethryth. (St Albans pageant, early twentieth century)

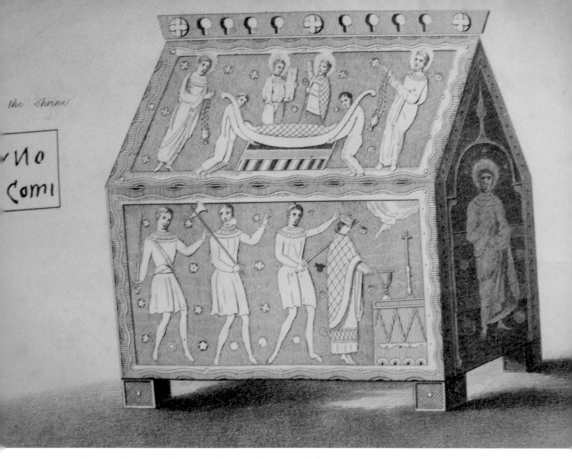

the Shrine

nic
comi

Medieval reliquary believed to be linked to St Ethelbert. (Hereford Cathedral Library)

2. THE DOWNFALL OF WILLIAM GRISMOND

O come you wilful young men and hear what I shall tell,
My name is William Grismond, at Leintwardine did dwell.

Many of us would like to be remembered after our death but probably not in the way of William Grismond, who became the subject of an early broadside ballad on the dangers of lust and a warning to others to avoid his terrible fate.

By 1649 the village of Leintwardine in north Herefordshire had avoided most of the horrors of the recent Civil War. Four of the more adventurous young men of the village had gone off with a company of Royalist infantry that had passed through the village and a couple of the older men had left to join the clubmen,

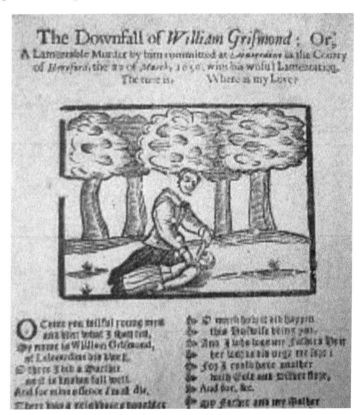

The brutal murder of Mary Watkins. (University of Glasgow Library)

local defence vigilantes who tried to protect their locality from the worst excesses of both armies. None of them had returned or any news come from them, so their relatives were slowly beginning to accept that they would not be coming back. The village had been scandalised by the news of the execution of Charles I and old men sat in the sunshine, shaking their heads and saying that no good would come of it.

William Grismond was the son of a well-to-do farmer in the district. The other young men of the village looked up to him because he rode a fine horse and had been to Hereford market on numerous occasions. As he rode along the country lanes his eyes spotted Mary Watkins, the daughter of a neighbouring farmer. He had known her since childhood but now he saw that in the last few years she had taken on a very pleasing shape.

While the Grismonds were rich the Watkins were poor, grubbing a living on a few acres. Naturally Mary was flattered when, one evening, William got down off his horse and engaged her in amusing conversation.

One thing led to another. It was coming up to the Christmas season and William used that as an excuse that they should celebrate this period of license in their own private way. Mary saw it as an opportunity to improve her lot and that one day she would be the mistress of a fine farmhouse. William did not disabuse her of the idea.

His parents were not fools and they saw the way their son was looking at the village girls. They therefore entered into negotiations with another prosperous farming family from Kingsland. When told of this William was delighted, thinking of the money that would come with this heiress and what he would be able to do with it.

But a couple of months into the new year, Mary came to see him. 'I am with child sweet William. Please marry me as you promised. Otherwise I will be ruined.'

William's mind was a witch's cauldron. His own prospects would be ruined if he agreed to wed Mary and she would denounce him if he did not. He sent word to her to meet him at a patch of scrub and gorse just outside the village. They say that, if gorse is out of bloom kissing is out of season and, by March, there was the heady scent of the blossom and a fine show of the yellow flowers as the two met and William kissed Mary's lips.

Then he quickly took his knife from his coat pocket and slit Mary's throat before she knew what was happening. He hid her body amongst the gorse bushes and went back to Leintwardine to pretend that nothing had happened. When Mary did not return that evening a search was made for her, getting more desperate as she was not found. After three days someone thought to search the patch of scrubland and Mary's awful fate was discovered.

You cannot keep anything secret in a small village and, although William thought he had been discrete, he saw the way that the villagers were starting to

Gorse bush – a good place to hide a body. (Irek Marcinowski from Pixabay)

look at him. Fearful of the consequences he saddled his horse and rode to Chester, where he sold it to pay for a passage to Ireland. But sailors are a superstitious lot and, the way the wind and currents were against the ship, they knew that there was someone evil on board. They persuaded the captain to return to port. There the news of Grismond's crime had reached the authorities. He was arrested and sent to Hereford.

His father offered all his gold to the Watkins family, but they would have none of it – blood must have blood. William went to the gallows repentant, apologising to his parents for bringing ignominy upon them even though they had brought him up well and hoping that his dreadful example would warn other young men not to give into the sin of lust as he had done. A ballad was composed to commemorate his crime that was very popular in its day. Unfortunately, way too many other examples of men killing their sweethearts have occurred since.

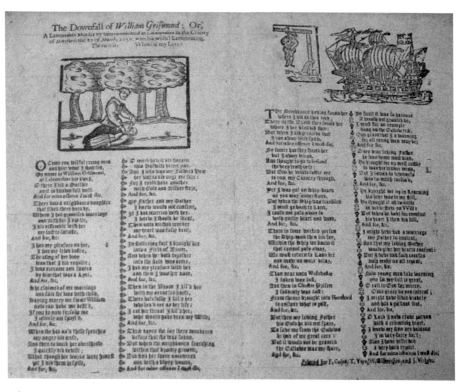

Above: Broadside ballad of William Grismond. (University of Glasgow Library)

Below: The sad fate of William Grismond. (University of Glasgow Library)

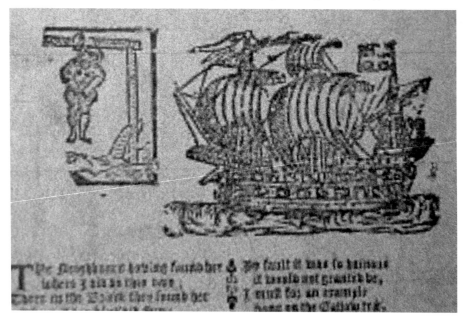

3. HEREFORDSHIRE WITCHES

A popular misconception of what a witch looks like. (Gordon Johnson from Pixabay)

Witches have been present in every human society, but the kind of witch depends very much on what kind of society. Before the introduction of germ theory in the nineteenth century medical doctors often did more harm than good, so it was probably a good idea to have people, often but not inevitably women, who had a knowledge of healing herbs.

Sadly, there was also a darker side. It is human nature to look for scapegoats when things go wrong and all too often it was poor and elderly women who fell foul of the community and were punished as witches.

Despite the popular misconception, those accused of witchcraft were usually hanged rather than burned, burning being usually reserved for heresy against the Church or for a woman who had murdered a social superior such as her husband. Punishment was often based not on the crime but on the social standing of the condemned, with lower orders facing methods of execution that took longer and hence increased level of shame.

The most renowned Herefordshire witch was actually a man who went by the name of Jenkins in Ella Mary Leather's seminal work *Folk-lore of Herefordshire*. It was not his real name but, even after his death, a respectable middle-class

woman like Ms Leather thought it prudent not to identify him too closely. Throughout the county he was credited with being a clever man, the local term for a cunning man. He was skilled in both medicines and charms as well as finding lost property. While he would charge for the medicine, he was careful not to charge for charms. This was a time, in the nineteenth century, when respectable people frowned on such stupid superstition and felt they should do everything they could to eradicate it.

Inevitably Jenkins was brought before the magistrates for being an imposter.

'So my man,' said the chief magistrate condescendingly, 'I believe you claim to have power over the local witches.'

'So I do.'

'Since witches do not exist that can't be such a difficult power to have.' This produced fawning laughs from his fellow magistrates.

'Perhaps I can convince you,' said Old Jenkins, and he gave the bench a dark look that made them sit up and take notice. 'I can bring 'em here if you want to see 'em. Do you want 'em brought in a high wind or a low one?' They declined either way and Jenkins was dismissed without penalty to the great advantage of his reputation.

Ella Mary Leather's grave, St Peter and St Paul's Church, Weobley. (David Phelps)

In 1662 Mary Hodges, a widow, was informed against, suspected of forespeak, the bewitching of animals. One horse had died suddenly and another was sick, both belonging to a man whom she had been heard cursing. Unfortunately the outcome of the trial is not recorded but shows the danger old women without protection might face.

In a time before effective veterinary medicine, the sudden death of a valuable animal could spell disaster. It was perhaps not surprising that it was often attributed to human and evil influence rather than just bad luck. Pigs were often the victims of this perceived spite, perhaps because they were the only livestock a poor cottager might possess. One man, whose pig was failing and believed to have been bewitched, was told by someone who said she knew to cut off its tail and throw it in the fire. Remarkably this shock tactic was reported to have worked. Other witches, rather than make pigs sicken, were said to have the ability to make them dance when they whistled.

The wasting away of humans was also generally attributed to witchcraft. A mason who lived at King's Pyon fell ill and could not work, yet no doctor could find anything wrong with him. Inevitably it was decided that a witch had

Weobley. (David Phelps)

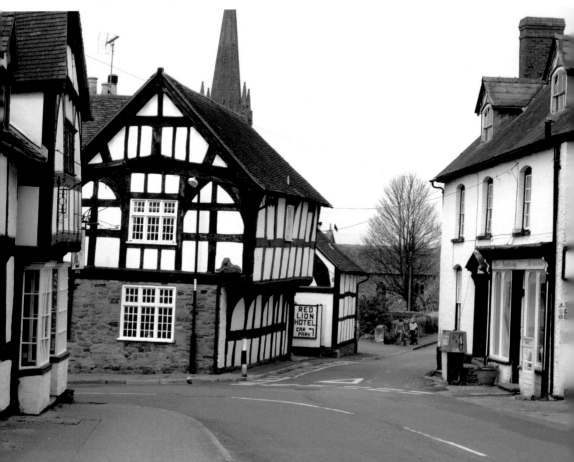

put a spell on him. A fire was made in the chimney and, at twelve o'clock, a large quantity of broom was stacked upon it and suitable incantations said. Before too long old Charlotte, a woman of the village, came in, she having no power not to do so, having been fetched. The family set about flogging her and the only escape for her was up the chimney. From that moment the mason revived.

People learned not to upset people considered to have special powers. In Weobley a policeman arrested a man for being drunk and it was generally thought that the man's mother was a witch. A passer-by saw the policeman struggling and came to his aid. When he got home his wife was greatly upset and was convinced they would suffer for it. Sure enough, the next week their pig died.

For centuries the existence of witches was a source of fear, that they would bring chaos on the community. This began to change with the counterculture of the 1960s and '70s, when many people started to see witches as a link to the old pagan, pre-Christian nature religion. In 1972 some schoolboys were exploring an old mica mine in Penyard Woods near Ross-on-Wye, disused for over fifty years. Stumbling deep into the mine with only a torch to guide them, they were disturbed to come upon a knife on the floor with a sinister curved blade carved with the signs of the zodiac. This was enough to convince them that they had

Penyard Woods. (Valerie Dean)

come across something that they should not have seen and they beat a hasty retreat, swearing that they would not speak of this to anyone else.

But, the following year, one of the boys got talking to some American tourists and could not resist telling them the story. They in turn persuaded him to show them the site. Exploring further, they found candles along the walls and a large, triangular altar-like stone on which was a small brass bowl, painted red, yellow, blue and green, in which was some mysterious white powder. They also found joss sticks and a tall beaker covered in strange symbols, a bull's horn and a white cloth with the picture of a goat. Most of the artefacts were taken back to America by the tourists.

An expert from Hereford Museum was consulted and his opinion was this was the work of white witches, not devil worshippers. There was no trace of blood and black magic is usually practised by the rich in the privacy of their own homes; this communal site was likely the work of people trying to do good.

However, the Forestry Commission was concerned that the publicity would attract the inquisitive, who might get into trouble. It was decided to blow up the entrance to the mine with gelignite but the resulting explosion only succeeded in making the entrance bigger. Not to be beaten by unseen forces, the Forestry Commission brought in a bulldozer to cover the entrance with soil and debris, forcing whoever was using the cave for their rituals to find another site.

It is commonly believed that there will always be nine witches between the bottom of Orcop to the end of Garway Hill in southwest Herefordshire. Similarly, there will always be a witch in Almeley, west Herefordshire, say the people who know, for as long as water runs.

4. THE HEREFORDSHIRE HIGHWAYMAN

A romantic idea of a highwayman.

Since Roman times young people of Herefordshire have often felt that they need to leave the county in order to better themselves, usually choosing London as their destination. Such a man was William Spiggot, the son of the innkeeper of the Chief Inn in Hereford. He was apprenticed to a joiner but quickly decided that there were easier ways of making a living, though his choice of career was slightly unusual. He decided to be a highwayman.

In this he was very successful: during a twelve-year crime spree William and his gang carried out many daring robberies on the roads around London. As well as money one of the main attractions of the profession of highwayman was the fame that it brought and William was soon one of the most notorious highwaymen around.

His luck ran out early in 1721, as it so often did for the followers of this profession. Spiggot was captured by the notorious thief-taking gang of Jonathan Wild, themselves men who sailed very close to illegality. Spiggot was described as very reluctant to be taken, perhaps unsurprisingly. He fought back, shooting the landlord of the establishment in which he was captured in the shoulder.

At his trial at the Old Bailey he refused to plead, perhaps hoping that, if he was not found guilty of any crime, his savings from his life of crime could be passed

on to his wife and children rather than going to Wild's men, the reward they could expect if their victim was convicted.

But the punishment for refusing to plead was a terrible one. He was taken back to Newgate Gaol, to be pressed with heavy weights until he decided to make a plea or died, whichever happened first.

He was forced to the ground and an iron weight of 350 pounds (160 kg) placed on his chest. After half an hour a further weight of 50 lbs was added. In incredible pain Spiggot agreed to plead.

At his trial he pleaded not guilty in one last desperate attempt to protect his family from the ignominy of having a convicted felon as a husband and father. He was accused of robbing one John Watkins on the highway, stealing a silver watch, a holland gown, a pair of stays, a scarlet riding hood with silk lining and five pounds of money. He was also charged with robbing John Turner, stealing five guineas, a box, a gold watch, twelve holland shirts, two pairs of lace ruffles, two cambrick bosoms (part of a dress covering the chest), two lawn and two muslin turnovers (type of collar), two pairs of stockings and a periwig.

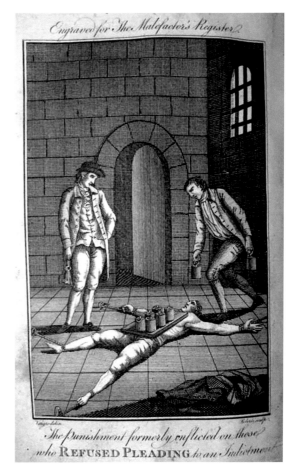

Pressing with weights.

While Turner was unable to identify Spiggot because the robber wore a mask, some of his stolen goods were found at Spiggot's lodgings. Watkins did recognise Spiggot, saying that he had previously known the man.

Inevitably he was found guilty and sentenced to hang. The chaplain of Newgate described him as penitent and the scene where he said a final goodbye to his young son brought tears to even that hardened man.

Sentence was carried out at Tyburn, now the site of Marble Arch, on 11 February 1721. Hanging at that time was a cruel, slow strangulation. The death throes of the condemned was popularly known as the Tyburn Jig. No one thought of the long drop, where the spine would be quickly broken for another 150 years. After Spiggot was finally pronounced dead, a crowd seized his body, to prevent it being taken for medical dissection and took it to his wife, so that it could receive a proper Christian burial, no doubt impressed by Spiggot's bravery.

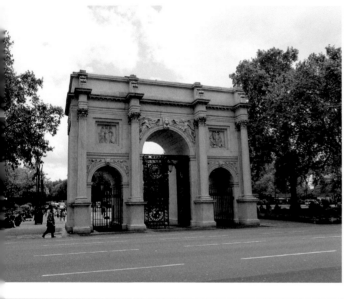

Marble Arch, the site of the Tyburn Gallows. (Falco from Pixabay)

The inevitable end for a highwayman.

5. THE TRAGEDY OF MARY MORGAN

By the end of the eighteenth century poor young women had very few work prospects. While some might chance the foul conditions but better pay of the increasing number of factories that were being established, for most young women domestic service was the only job on offer. Here they needed luck. Among their fellow servants they might hope to meet a man they could settle down with; above all they would need a good employer who would look after their interests. The worst was that they would face sexual harassment from the men in the household, seduction or even rape. They, not the men, would be blamed and they could have little choice but to drift into sex work.

Mary Morgan was born in the small village of Llowes, near Hay, in 1788, the daughter of poor farmworkers. To support her family, at the age of fourteen she was found a position as a kitchen maid at Maesllwch, one of the local big houses, then owned by Walter Wilkins, who had made a huge fortune in India and had retired to the Welsh border to enjoy his wealth.

By 1804 Mary had been promoted to undercook, so must have impressed Elizabeth Evelyn, the head cook. At midday on Sunday 23 September of that year she was struck down with a terrible pain in her stomach and became so unwell that she could not carry on with her duties and was told to go back to bed. Her fellow servants checked on her throughout the afternoon and all later reported that she had been in terrible distress. When Mary Meredith, who shared Mary Morgan's bedroom, tried to get into the room in the early evening she found it locked and was refused entry on the grounds that Mary Morgan needed to sleep. The cook and another servant, Margaret Havard, went up straight after and insisted on entry, where they found Mary looking very like someone who had been in labour. Mary denied this 'with bitter oaths', but, on repeated questioning, eventually agreed that it was true. She then presented the two women with a horrific sight.

The newborn had been concealed in the feathers of the mattress, its head almost detached from its body and its intestines also hidden under the bed. Later a bloody silver penknife was also found at the scene. Her employer, Walter Wilkins, was informed. As High Sheriff of Radnor he had no choice but to inform the County Coroner. Because of her condition it was two days before she could be taken to Presteigne Shire Hall, a journey that she was required to pay for and where she would be incarcerated for six months in squalid conditions.

Eventually the Great Sessions commenced, on 8 April 1805, Mr Justice Hardinge, senior justice of Breconshire, Glamorgan and Radnorshire presiding. Despite her six months' misery she was described by the judge as serious,

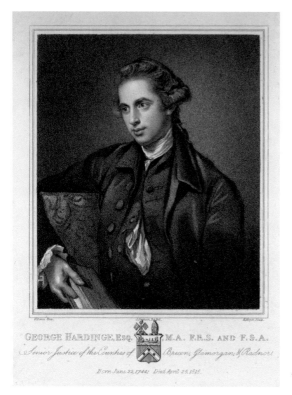

GEORGE HARDINGE, ESQ. M.A. F.R.S. AND F.S.A.
Senior Justice of the Counties of Brecon, Glamorgan & Radnor
Born June 22,1744; Died April 25,1816

Judge Hardinge. (Presteigne Shire Hall Museum Trust)

attentive and intelligent. Her tale was an all too common one. She had been in a relationship with another servant who, on being told she was pregnant, refused to be of any help to her other than to give her a herbal drink that would secure an abortion. This she refused to drink. She had explained to young Walter Wilkins, the eldest son of Walter senior, that she was pregnant and he had offered to maintain the child as long as she named him as the father. This she refused to do, since he was not.

From her remarkably cheerful demeanour she may have hoped to escape the death penalty. Walter Wilkins junior was one of the jurors and she might have hoped that he would have approached the judge for clemency. She might also have heard that Justice Hardinge had recently presided over a similar case in Brecon where the girl had been only sentenced to two years' imprisonment for concealing a birth.

But, on hearing the testimony of her fellow servants, the jury gave a verdict of guilty on the unfortunate young woman, still no more than seventeen years of age. Justice Hardinge therefore pronounced the death sentence, although those present in the court were amazed to see tears flowing down his cheeks as he did so. Even so he fulminated at great length, telling the court, 'To cut off a young creature in the morning of her day ... is an affliction thrown upon me which I have no power to describe or bear so well as perhaps I should.'

Above: The site of Presteigne Courthouse, now a greater boon to humanity. (David Phelps)

Right: Small towns might not have had their own gallows but employed a convenient tree. (David Phelps)

For all that, he stated that the execution should be carried out within forty-eight hours and that Mary's body be dissected and anatomised. Popular local legend says that a reprieve was sent from London but, because of the quickness of the execution, it did not arrive in time. She was taken by cart along Gallows Lane to the hanging tree. It was said she was so emaciated after six months' imprisonment that a man had to be employed to pull on her legs after the hanging to ensure her neck was broken. At least some of the crowd who had come to witness her death were able to cut down her body from the gallows and buried her in the garden of the rectory, saving her the final ignominy of dissection. That area has since been incorporated into the graveyard of St Andrew's Church, so her body now lies in consecrated ground.

Even at the time people were surprised by the behaviour of Judge Hardinge. Why was a battle-hardened judge, used to passing death sentences, so moved by this case? There was also the fact that, as a Circuit Judge, Hardinge travelled regularly in the area and was known to have stayed at Maesllwch in April 1804 when he could have encountered the pretty kitchen maid. Did he have more of a personal interest in the case than he was prepared to admit? He would have known that there had been no capital convictions for this type of crime at the Old Bailey in the last twenty years, and had himself recently been lenient to the girl in Brecon. Why did he make an example of the unfortunate Mary Morgan?

His subsequent actions did nothing to relieve suspicion. Every time his duties took him to the Presteigne area he always visited Mary Morgan's grave. He also composed several poems in her memory. In 1816 although suffering from a bad chest infection, he insisted on following his custom and going to the grave. There he collapsed and had to be carried back to his lodgings. He died three days later of pleurisy. Eleven years after her death, had Mary Morgan taken her revenge?

We shake our heads at the misery our forebears faced yet, while this book was still in draft stage, a grimly similar case played out in the English courts. A teenager from Ross who kept her pregnancy secret for fear of public shaming gave birth in silence and then killed the child. She was sentenced to twelve years' imprisonment.

St Andrew's Church, Presteigne. (David Phelps)

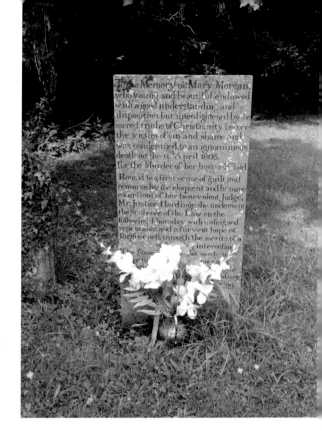

Right: Mary Morgan's grave complete with floral tribute. (David Phelps)

Below: Mary Morgan's second gravestone, crowd-funded by the people of Presteigne. (David Phelps)

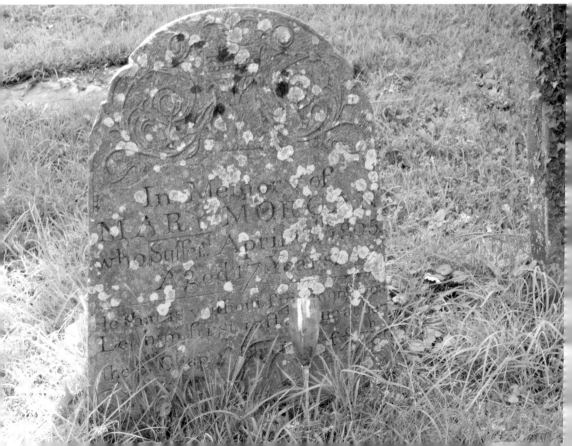

6. THE EFFECTS OF SLAVERY ON HEREFORDSHIRE

It was once thought that being a landlocked county, Herefordshire was not as implicated in the slave trade as such ports as Liverpool and Bristol. Unfortunately, current research shows that not to be the case. Like investment in the fossil fuel industry today, the business was just so profitable that investors, even though they knew it to be immoral, could not ignore it.

The first Englishman known to have become involved in the transatlantic slave trade, Sir John Hawkins, had Herefordshire connections. His second wife, Lady Margaret, was a Vaughan from the notable border family. Hawkins has the dubious distinction of persuading Elizabeth I to invest in the slave trade and made three slaving voyages, establishing slave trading routes from Plymouth.

Profits made from human misery went to enrich the great country houses of Herefordshire. Few of the county's mansions do not owe their magnificence to the money made by the blood and sweat of the Caribbean. In 1673 Ferdinando Gorges, known as the king of the Black Market, after a lifetime spent as both slave trader and plantation owner, retired to Eye Manor to live the life of a gentleman, using his fortune to turn the interior of the house into a fine example of late seventeenth-century decoration, especially the plaster decoration of the ceilings.

Moccas Court, the home of the Cornewall family, was enlarged and improved on the profits from large plantations in Grenada. Hope End, near Ledbury, was bought by Edward Moulton-Barrett in 1809 with money from slave plantations in Jamaica and re-modelled in the then fashionable oriental style, complete with minarets. Shortly after the project was completed, in 1812, there was a major slave revolt on the Caribbean Island. Although this was brutally suppressed, Barrett lost a great deal of his wealth and was forced to sell Hope End and move to London. Here his daughter Elizabeth met and married her fellow poet Robert Browning and was able to elope to Italy, away from her often tyrannical father.

But it was not just the wealthy who enriched themselves in the trade. The less wealthy of Herefordshire, the rising middle classes, also saw it as a way of supporting their lifestyle. They did not own slaves themselves but invested in companies that did. The notorious South Sea Bubble of 1720, one of the first crises of capitalism, was caused by the collapse of the South Sea Company, formed in 1711 to supply slaves to Spanish America. Many of the middling sort, including artisans from Herefordshire, faced financial ruin, an early example of the risks involved when investments go down as well as up.

Above: Eye Manor. (David Phelps)

Below: Moccas Court. (Phillip Pankhurst)

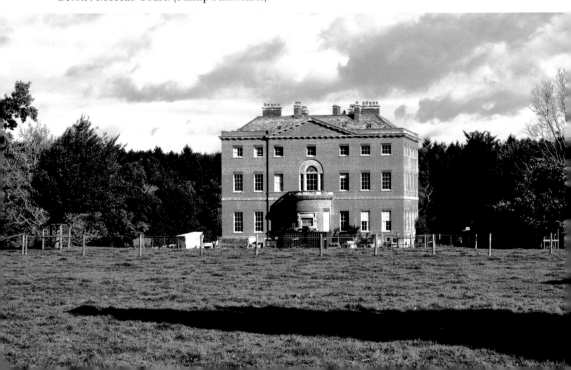

As popular feeling grew against slavery at the end of the eighteenth century it was the involvement of the middle classes, who did not want to lose their profits, that acted as a brake on any change. But others organised petitions to Parliament and a boycott of sugar. Even when slave ownership was eventually abolished, in 1835 the British government took out a large loan to compensate, not the freed slaves but their former owners. British taxpayers were still paying back the loan up until 2015. Ex-slaves received no compensation and were forced to continue work on the plantation, on terms and conditions little better than when they had been slaves.

When people are upset about the amount of foreign aid the UK gives to developing nations it is worthwhile considering the wealth extracted from these countries through slave exploitation.

Slavery memorial. (Efraimsochter from Pixabay)

7. THE CURSE OF BERRINGTON HALL

There are some places that just seem to be unlucky. While tragic events can occur anywhere some seem to attract more than their fair share, as if something malign was influencing events. Some people might think that was true of Berrington Hall.

Now owned by the National Trust and a popular destination for tourism, it was built by Thomas Harley, who was from an old-established Herefordshire family and who had made his fortune in banking and supplying uniforms to the British army during the American War of Independence. The building was finished in 1781, having cost a great deal more than expected, leaving Harley short of money, having to sell off part of the estate to keep the building works going. Nevertheless, he was able to employ the noted landscape gardener Capability Brown to create the park that surrounds the house, Brown having originally chosen the location of the hall as being suitable for his vision. It was to be his last project. He died soon after.

Capability Brown's last parkland, Berrington House. (David Phelps)

In 1796 Harley employed a gardener called John Fleet. It was a responsible position, ensuring that Capability Brown's vision was followed. Fleet was keen to improve his situation and, in that year, entered into negotiations with Robert Sibbering, a landowner in nearby Moreton, to purchase a small estate. To that end Fleet paid a deposit of £100, a quite considerable sum of money.

One Friday around midday several witnesses would later testify that they saw Sibbering and Fleet in intense conversation at the side of the canal near Sibbering's home, presumably finally settling the purchase.

But Fleet was not seen again. He was not seen at his house, did not attend church services on the Sunday, nor did he appear for work on the Monday morning. A man of sober and regular habits, this was so out of character that people started to get worried. Naturally Sibbering was questioned but maintained that the two men had parted on good terms after their conversation and he had no clue as to what had happened to Fleet after they left each other.

Berrington House.
(David Phelps)

Throughout that week Sibbering carried on as if nothing out of the ordinary had happened while a fruitless search for Fleet continued. Gossip abounded and no one could come up with a reason for the gardener's disappearance that did not involve Sibbering. Finally, on the Friday, the pressure must have become too much and Sibbering disappeared himself. This was generally taken as a confession of guilt and a search was now undertaken for him.

It is difficult to keep anything quiet in the English countryside and information was soon given to the authorities that they should search a cottage in Bircher, not 3 miles away from Moreton. There Sibbering was found still in bed. He did not seem greatly surprised by the interruption but calmly enquired if Fleet had been found.

Hearing that Fleet was still missing, he got out of bed and dressed himself. Then, before anyone could stop him, he took out a knife from the pocket of his coat and cut his throat. Despite attempts to save him he had made a sufficiently good job of it to die within three quarters of an hour.

A more comprehensive search was now made of Sibbering's house in Moreton and some recently disturbed ground was examined. Fleet's body was found buried there. Despite the length of time that had passed it bore the marks of a violent attack. One can only guess what had caused this tragedy. There is some dispute over the details, but the sale of the estate that led to an argument that got out of hand and led to Fleet's death is the most obvious conclusion. Whatever the circumstances, they led to the deaths of two men who had previously been considered respectable citizens, as if some dark influence was present.

Certainly Thomas Harley seemed to get no luck from Berrington, dying in 1804 without a male heir. His daughter Anne had married the son of the naval hero Admiral Rodney, himself quite a controversial character, whom many of his fellow admirals considered more interested in gaining prize money than working for the national cause. The Rodneys seemed to garner no more luck out of Berrington than the Harleys had, in the 1840s losing three male heirs within four years of each other. As we shall see in the following article, relations between the Rodneys and local people would remain tetchy.

8. SOCIAL UNREST

In the early modern period most disturbances were caused by religion. At the beginning of the seventeenth century southwest Herefordshire remained largely Catholic, despite risking heavy penalties from the establishment, who regarded them as potential traitors. On 20 May 1605, Alice Wellington died in the parish of Allensmore, just to the west of Hereford. As a Catholic who refused to attend the Anglican communion she had been excommunicated from the church and now the vicar of Allensmore, Richard Heyns, refused to give her Christian burial in the churchyard.

At around dawn on the 21st the vicar was forced awake by loud noises outside his window and, looking out, he saw a large funeral procession heading for the church. He dressed quickly but was too late to prevent Alice Wellington being buried and, on remonstration with the people, was met with curses and threats.

St Anrew's churchyard, Allensmore. (David Phelps)

Revd Richard Heyns was not in good odour with the bishop, having been found to rarely perform church services, perhaps demoralised by his Catholic parishioners. Now he was determined to improve his record and rode immediately to the bishop's palace in Hereford to inform him of what had happened.

On 24 May, the High Constable of the Hundred of Webtree arrived in Allensmore with warrants for the arrest of the men Heyns had recognised at Alice's funeral. They resisted arrest, two of the Constable's men were injured and he left with only one man, Leonard Marsh, in custody. But even he did not go quietly, struggling all the way to the city and, before they could reach Hereford, a mob of around fifty men overtook them armed with swords and bows and the Constable was forced to release his one prisoner. The events became known as the Herefordshire Commotion or the Whitsun Riot.

Fearing a general Catholic uprising, the authorities issued further arrest warrants, targeting the local gentry and farmers as well as ordinary villagers. This rendered the protests leaderless and they eventually fizzled out. Clearly the Protestant elite were right to be concerned by the dangers of Catholic discontent because, only six months after these events, the notorious Gunpowder Plot came very close to blowing up the House of Lords. Some historians take the view that, when young Catholic hotheads saw from events in Herefordshire how the new Jacobean regime was likely to treat them and their co-religionists, they decided that they needed to take matters into their own hands.

Herefordshire is often thought of as a quiet county, not given to violent protest. But appearances are deceptive. While the Captain Swing protests against rural poverty of 1830–1 barely touched it, only one man from the county, a twenty-year tailor called Henry Williams, was convicted for his part in the disturbances. By 1857 Herefordshire was rated one of the six counties in England with greatest amount of crime in proportion to the population, largely due to many people's discontent with their lot.

Throughout the eighteenth and nineteenth centuries rural protest centred on one thing: poverty. Enclosure of the common field system was looked upon by large landowners as a good thing, increasing crop yields and enlarging the population that could fuel the Industrial Revolution. But, for the small peasant farmer who relied on the livestock he could graze and crops he could plant on the common land it was a disaster. Now he was forced to seek employment with the large farmers who had done well out of the process or, worse, become a day labourer, reliant on whatever work he could find in the area. While we now see hedges as an aid to wildlife and seek to protect them, to our ancestors they were barriers of the devil that cut them off from the fields they were wont to walk in.

In Herefordshire there was an understandable feeling that the common man had been deprived of his rights and they blamed the farmers who had done well out of the changes. As the poet John Clare wrote in 1820:

Accursed wealth o'er bounding human laws
Of every evil thou remainst the cause
Victims of want those wretches such as me
Too truly lay their wretchedness on thee
Thou art the bar that keeps from being fed
And thine our loss of labour and of bread

People felt cheated, especially as notification of enclosure was often poorly advertised and meetings to approve enclosure were held some distance away so that the poor could not attend. What compensation was paid was soon gone. But it is not to be thought that the common man accepted this quietly. While the majority grumbled, a sizeable few took to acts of rebellion such as rick burning, poaching and sheep stealing.

At Newton Farm in 1849 a large crowd stood by and watched stables belonging to the farmer Mr Preece burn to the ground, offering no assistance at all but rather taking the opportunity to get a free meal as, among the casualties of the fire were some pedigree fowl, roasted in the flames and seized by the onlookers, torn to pieces, and eaten on the spot. Farmers, by being too studious in prosecuting local people for petty thefts, could bring down the wrath of the locals upon themselves. In 1850 a farmer from Goodrich ejected some people from his pea field where they were undertaking the age-old custom of gleaning, taking what had been left after the harvest, but in his view it was stealing. Shortly after he lost a rick to fire, losing 200 bushels of wheat.

If a man feels the pangs of hunger it is hard to know that his landlord is killing pheasants and hares purely for sport. It is not surprising then that poaching figures prominently in lists of crimes brought before the magistrates. It was a risky profession – the Game Laws sought to protect the rights of the landowner over those of the hungry. The convicted faced fines of 5£, way in excess of what the poor could pay and they therefore faced imprisonment, which in turn would force their family into the workhouse. Gamekeepers, the enforcers of the law, risked more than unpopularity, especially if they were considered too enthusiastic. The following note was found in one of the cannons at the front of Berrington Hall in 1811:

Berrington shall shine in the dark, the keeper shall die by the gun... You had better send Bridgewater home again (Rodney Bridgewater was gaoled, whipped and conscripted into the army for assaulting the gamekeeper, William Taswell the previous winter). That keeper had better go back to Derbyshire for if he

stays here he shall surely die. He is not going to be master of us tradesmen...
Berrington will have a fine lamp some dark night.

The gravest crime that took place was animal maiming and sheep stealing. Horses
were the most common victim of attacks. In 1839 the stomach of a valuable pony
belonging to Mr Archibold of Barrs Court was slashed open. In 1857 a couple
of colts belonging to a farmer at Marden had their ears and tails cut off, the
unfortunate creatures standing as surrogates for unpopular gentry.

Sheep stealing seems to have been predominately carried out in east and
south Herefordshire, especially around Whitchurch, where the authorities were
convinced family gangs were operating for profit. Most crimes, however, were
desperate acts of survival. Ann Perkins, described as a miserable old lady, cut
the throat of a ram in Aconbury in 1830 with her penknife. She then butchered
it and hid the joints beneath a hedge. She pleaded in her defence, 'My lord, I was
perishing from hunger when I caught the ram and I was almost ready to eat the
wool off the skin.'

Horses were targeted by the angry poor. (David Phelps)

The Doward near Whitbourne, believed to be a den of poachers. (David Phelps)

At the 1827 Assizes Thomas Taylor was found guilty of stealing a sheep from Mr Bond, a farmer at Linton. He was sentenced to transportation for life. That this was an unpopular verdict with the community can be guessed because shortly afterwards Mr Bond's dogs were found with their throats cut.

9. MISERY AT MUCH MARCLE

St Bartholomew's churchyard, Much Marcle. (David Phelps)

The village of Much Marcle, to the west of the market town of Ledbury, is well known by aficionados of true crime as the birthplace of the serial killer Fred West. Since his crimes took place in Gloucester, we will have no need to detain ourselves with him any further.

But the village has not been immune to other tragedy. In 1842 events occurred that would not be out of place in a Thomas Hardy novel.

In that year Milborough Trilloe was a thirty-year-old widow with three children to look after. She shared a rented cottage with Sarah Scrivens, an unmarried

woman with two children of her own, another four having been stillborn. They both worked as unskilled farm labourers, taking what work they could around the neighbouring farms. Milborough earned a little extra by taking in washing for their landlord, a widowed gentleman by the name of James Taylor. It was already noted in the village the unusual frequency with which Taylor visited the cottage, sometimes up to ten times a day.

In the spring Milborough Trilloe's acquaintances noticed specific changes in her body that led them to think that she was expecting another child. She vehemently denied that this was true but, as the pregnancy progressed, she had to admit that this was indeed the case.

Sarah Scrivens became angry with Milborough because she seemed to be making no preparations for the birth of the child, but Milborough told her that she was convinced the child would not survive as it was too restless in the womb.

In the early morning of 24 June Milborough complained to Sarah that she was feeling very cold, even though the weather was quite fine. Sarah took this as a sign that the baby was due, but she had no option but to leave the house and walk to a nearby farm to hoe weeds. The household needed the sixpence that she would be paid for that work.

Labourers' cottages were often of poor quality. (David Phelps)

At around eight o'clock that evening Sarah returned from work to find that Milborough was still in bed. She questioned her friend about the day and was told that she had suffered a miscarriage and James Taylor had already buried the body of the child. Sarah wanted to send for Mrs Baldwin, the local midwife, but Milborough said that she already had but the old woman had refused to come. Sarah was further distracted by an accident that had befallen her daughter and that had left the child with a nasty burn. When James Taylor turned up again later that evening he advised the two women that they should apply a raw potato to the injury.

Such were the demands of their poverty that Milborough returned to work only two days later. If anyone asked she told them the same story, that the baby had been born dead and Taylor had buried it for her, but when Taylor heard this gossip he was horrified because it implicated him in the crime of concealing a birth. He confronted Milborough and she now changed her story slightly, telling him that she had buried the baby herself, in a field owned by Taylor's cousin John.

James Taylor was still very angry with what he had heard and he went to the village constable, Samuel Griffiths, who arrested Milborough for the crime of infanticide. Griffiths made her show him where she had buried the baby and she took him to a ditch at the edge of a neighbouring field. To Griffiths the ground looked undisturbed, but he had brought a spade with him and started digging. He found nothing. Milborough said that the baby had been such a small thing that it had probably wasted away. She refused to change her story and Griffiths was forced to search the village looking for disturbed soil, eventually finding a small patch of earth in the corner of Taylor's garden. After some digging, he found the body of a baby.

After a medical examination, it was determined that the body was that of a full-term baby girl whose lungs indicated that she had been born alive. There were also marks of violence on the child's neck.

Milborough's story now had to change again. She said that she had given birth shortly after Sarah Scrivens had left for work. While the baby had been born alive, she was in so much pain that she had grabbed hold of the child's neck and accidentally strangled her.

Griffith was a conscientious parish constable – not necessarily a given at that time. He went back to the wretched temporary grave to make further examinations. It became obvious to him that it would have taken some considerable effort to dig that hole, more than a woman who had recently given birth would be capable of. He therefore also arrested James Taylor. When Taylor was brought in for questioning, he caught sight of Milborough and complained, 'You have brought me into a fine scrape.' However, no further evidence could be found to link Taylor to the crime; indeed, he had first contacted Griffiths to voice his suspicions. All charges against him were dropped.

An inquest was held into the child's death and the jury brought back a verdict of wilful murder. The case opened at Hereford Assizes on 3 August 1842. John

Taylor gave evidence that he had seen Milborough on the morning of the 24th, fully dressed and looking shocked and frightened, which he had attributed to the accident of Sarah's child. Constable Griffiths had to defend himself from accusations made by the defence that he had damaged the body while exhuming it but the main line of defence was that Milborough was so beside herself with the pain of childbirth that she did not know what she was doing when she clutched onto the baby's throat.

It took the jury ninety minutes to consider all the evidence and when the verdict came it was guilty of wilful murder but with a recommendation for mercy. Milborough Trilloe collapsed in the dock on hearing the verdict and had to revived by Dr Bull, one of the medical men present, so that she could hear the sentence of death pronounced upon her.

Here then followed a year of legal wrangling. The defence had objected to one piece of the medical evidence and this was placed before fifteen judges for their opinion. The *Hereford Times* was rather coy on what the discussion was about but it seems that medical opinion was that the baby was still attached to the umbilical cord at the time of death, but crucially able to breath independently, therefore making it a case of murder. They were also of the opinion that the child was strangled with a handkerchief or cloth. Eventually, in November 1843 it was announced that the death sentence had been commuted to transportation for life. Milborough Trilloe was sent to Van Diemen's Land, the island now called Tasmania, or Lutruwita in the indigenous language, never to see Herefordshire or her children again. They would face the miseries of the workhouse.

Milborough Trilloe set sail from the port of London on 30 November 1843, on the *Emma Eugenia*, in the company of 169 other female convicts and the male crew. The ship did not arrive at its destination until 2 April 1844. It must have been a terrible voyage, not only because of the cramped and squalid conditions but also because the route took it through the Bay of Biscay and the Cape of Good Hope, two of the roughest seas in the world.

We think of transportation as a terrible fate. In truth conditions for the poor in Herefordshire were so bad that many welcomed it as a way of starting a new life. Certainly, Milborough seemed to be trying to make the best of a bad lot. She remarried in April 1846 to Thomas Parsons. However, tragedy was to strike again. In April 1852 he fell off the back of a bullock cart and the wheels went over his head, killing him instantly.

Milborough received a pardon in September of that year, after which she passes out of the record books. It is unlikely that she ever found the money for her passage back to England.

10. THE TUPSLEY MURDER

Psychologists are divided about the value of premonitions. Some who have studied the matter think they might offer clues to patterns in events that some people are able to discern, others that they are just fears that sometimes come true – but mostly don't.

Whatever the truth, in 1887 Phillip Ballard of Tupsley told a friend that he had started having dreadful thoughts that he would shortly meet with a violent death.

Ballard was one of the least likely people in Hereford to be liable to meet such a fate. He was as old as the century, nearly blind and noted for his kindly disposition. He was the son of a Malvern solicitor and had become a successful artist, especially in the field of china painting and enamelling. He lived at the Knoll, a large Victorian house with extensive grounds close to St Paul's Church, where he had served as churchwarden for many years.

In the early hours of 20 October Ballard's housekeeper, Margaret Weaver, was woken by the sound of terrible groans coming from her employer's bedroom. On investigation she was met by the ghastly sight of Mr Ballard lying in his bed with two head wounds still gushing blood. In deep distress, the first thing she thought to do was rush to the vicarage and get help from Revd Thomas Canning. The clergyman, when he arrived, did everything he could to halt the flow of blood and keep his parishioner alive but, further medical help arriving, it soon became clear that Ballard's injuries were likely to be mortal, and so it proved, although it took him a further four and a half days to die.

The city of Hereford was in a state of shock. Who could have committed such an atrocious crime against a defenceless old man? An inquest had to be held and, in those days, it was required of the jurors to view the body. Theirs was a grisly task; the face was horribly discoloured, in some parts having turned black. Murder by persons unknown was the only possible verdict.

The police were clear as to the motive: the Knoll had been ransacked and his sizeable collection of jewellery and other valuable items were missing. The Ballard family put up a substantial reward of £150 for information leading to the conviction of the culprits and soon the police started receiving names, two in particular: James Jones, a twenty-three-year-old barman whose parents lived nearby; and Alfred Scandrett, also twenty-three, a gardener. They had met each other while imprisoned in Reading Gaol. A Birmingham jeweller came forward to say he had been offered some of the stolen items by the two men, whom he could identify. A Ledbury ironmonger could also identify Jones as the man to whom he had sold a jemmy the day before the murder. Railway staff could remember the two men travelling between Ledbury and Withington, the only third-class tickets

sold on that day. Hilo Williams, barman at the New Inn, Lugwardine, recalled both men getting through a quart of cider on that fateful evening. He also gave the damning evidence that he had noticed that Scandrett was wearing clogs. A clog with blood spattered on it had been found in a field at nearby Eign Hill. George Parry, a postman, said he had seen the two men lurking in the gloom of that October evening at Tupsley Pitch and they had caused his horse to shy and upset a basket of apples in his cart. As well as the more valuable items, Scandrett had sold some boots identified by Charles Owen, a shoemaker in St Owen's Street, as those he had made for Mr Ballard. They were very distinctive as Mr Ballard had a large bunion on one foot and the shoe had to take account of this.

While Mr Ballard was regarded as a fine old gentleman in respectable parts of Hereford, it became clear that the jewellery and other riches that he had in his house was also the cause of endless speculation in the poorer quarters of the city and it was probably this gossip that gave Jones and Scandrett the idea of the robbery.

Scandrett and Jones were apprehended and brought before Hereford Winter Assize, Lord Justice Coleridge presiding. The evidence against them was overwhelming but both pleaded not guilty, each blaming the other for striking the fatal blows while they had been only bystanders. During the trial Scandrett's sister fainted as the evidence against her brother mounted up and it was Ballard's niece who went to her aid. The judge became very angry when he discovered that the jury members, lodged at the Green Dragon Hotel, had been able to discuss the case with outsiders and fined the court officials deemed responsible the considerable sum of £20 each.

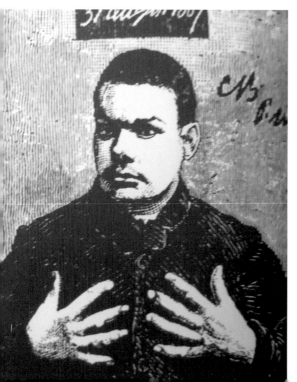

Alfred Scandrett. (*Hereford Times*)

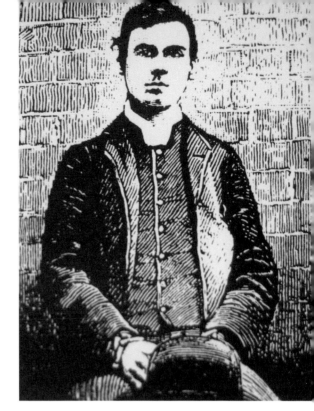

Right: James Jones. (*Hereford Times*)

Below: The Green Dragon. (David Phelps)

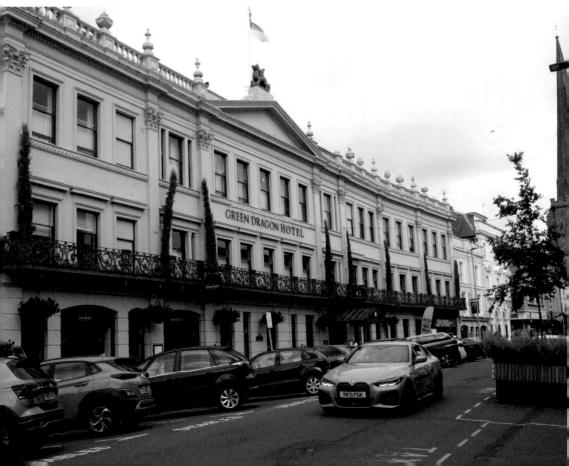

In the end it took the jury just over five minutes to find both men guilty. As Lord Justice Coleridge donned the black cap in preparation for sentencing both men to death Scandrett started trembling and he was convulsed by heavy sobs. He started muttering, which some of those present took to be a prayer and they responded, 'Amen!'

'May the Lord have mercy on my soul!' cried out Scandrett, who then launched himself at Jones in an apparent attempt to strangle him, before being restrained by his warders. Jones was quickly led away and Scandrett assured the court that he would not cause further trouble.

The two men were due to hang on 20 March 1888. Shortly before this George Parry, the postman who had given evidence against the two men, was found in his lodgings dying from a laudanum overdose. Despite his stomach being pumped nothing could be done to save him.

Sentence was duly carried out by James Berry, the public hangman. A remarkably tender-hearted soul for a hangman, Berry devised a table setting out a weight/length of drop ratio that would deliver instantaneous death by dislocation of the neck. Too short a drop would lead to slow strangulation. Too long and there was danger that the head would be pulled right off. Both men were described as going quietly to their fate, if white-faced and agitated. At their inquest the prison chaplain read out confessions from both men, Scandrett admitting that it was he who struck the two fatal blows with the axe.

James Berry's calling card. (Ronald Meek)

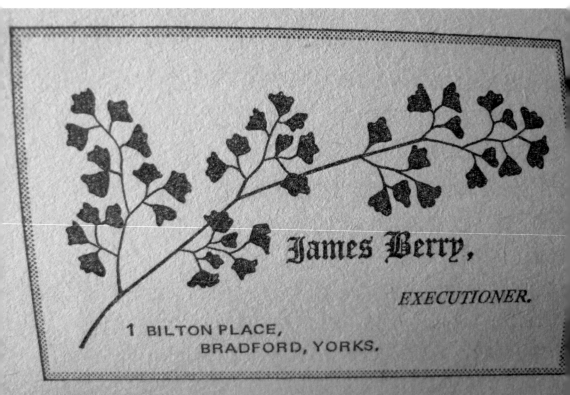

James Berry,

EXECUTIONER.

1 BILTON PLACE,
BRADFORD, YORKS.

Weight in Stones	Length of Drop
14	8 ft. 0 in.
13½	8 ft. 2 in.
13	8 ft. 4 in.
12½	8 ft. 6 in.
12	8 ft. 8 in.
11½	8 ft. 10 in.
11	9 ft. 0 in.

Berry's table to determine length of drop. (Ronald Meek)

Weight in Stones	Length of Drop
10½	9 ft. 2 in.
10	9 ft. 4 in.
9½	9 ft. 6 in.
9	9 ft. 8 in.
8½	9 ft. 10 in.
8	10 ft. 0 in.

Length of drop for the lighter person. (Ronald Meek)

Left: St Paul's, Tupsley.
(David Phelps)

Below: Phillip Ballard's
grave, St Paul's churchyard.
(David Phelps)

11. MAJOR ARMSTRONG

Major Armstrong. (*Hereford Times*)

In the respectable town of Hay-on-Wye on the Herefordshire/Wales border, one of the most respectable of its citizens was Major Herbert Rouse Armstrong. He was one of the town's solicitors, so was a respected a pillar of the community. He was a freemason and a member of the Conservative party.

Armstrong was born in Plymouth in 1869 and had been a practising solicitor in Hay since 1906. He had married his wife Katherine in 1907 and their affection for each other had been noted by the community. They settled in Mayfield, a detached villa in Cusop Dingle just outside Hay where they raised three children. In the First World War, given his age and being only 5 foot 6 and weighing 7 stone, he was judged not fit for front line service, but his solicitor's attention to detail made him a valuable asset behind the lines in the Royal Engineers. By the end of the war he had reached the rank of major. He was immensely proud of this honorific and chose to retain it.

Katherine Armstrong.
(*Hereford Times*)

Hay at this time had two firms of solicitors, likely more than it could support, a possible factor in the story that follows. Their offices faced each other in Broad Street. Armstrong had become senior partner in the firm Armstrong and Cheese, the previous senior partner, Edmund Cheese and his wife, having died within twenty-four hours of each other in 1914. The other firm of Robert Griffith had recently taken on a new solicitor, Owen Martin. Although invalided out of the army with one side of his face paralysed, he was a dynamic young man of thirty and later reports indicate that Armstrong felt threatened by him as the major tried to revive his business after the war. Martin had also angered Katherine Armstrong by arriving for afternoon tea at the Armstrongs' house, Mayfield, wearing casual dress rather than the formal suit expected. With that, and the fact that Martin's wife was often seen wearing fox furs, the Armstrongs considered the Martins rather vulgar.

In 1919 Mrs Armstrong developed pains in the shoulder and arm. The local doctor knew her as a hypochondriac and put it down to rheumatism. Initially improving, her condition deteriorated at the end of the summer. She became depressed and her behaviour erratic. Eventually it was decided the best course of action was to confine her to a private mental asylum near Gloucester. Although her health improved, Katherine hated it there and persuaded her husband to let her return to Hay.

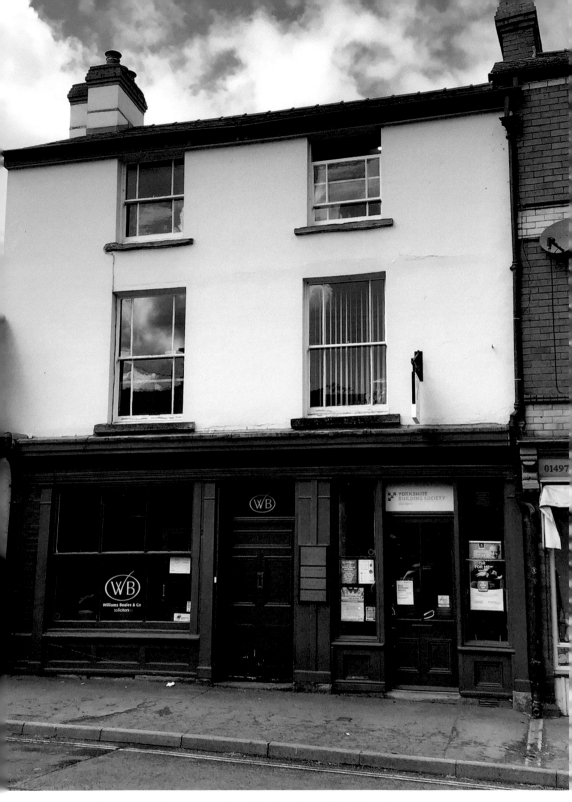

Major Armstrong's former practice, still a law firm. (Valerie Dean)

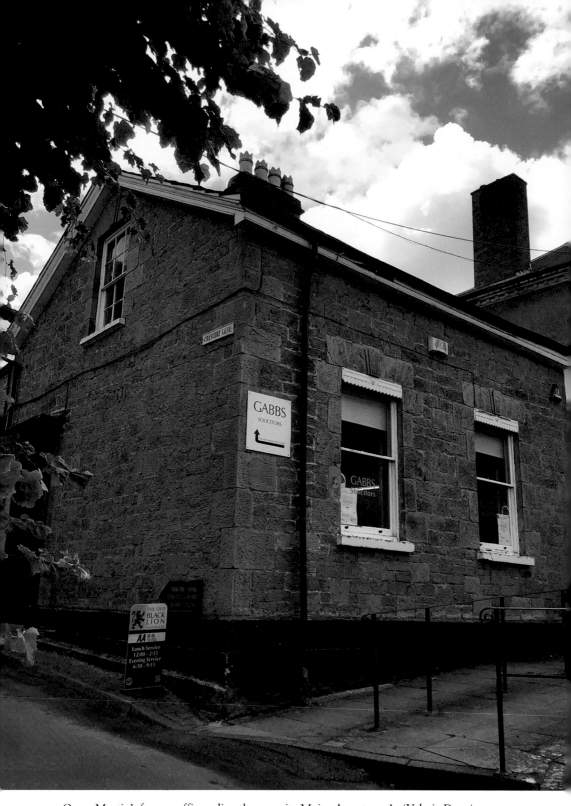

Owen Martin's former offices, directly opposite Major Armstrong's. (Valerie Dean)

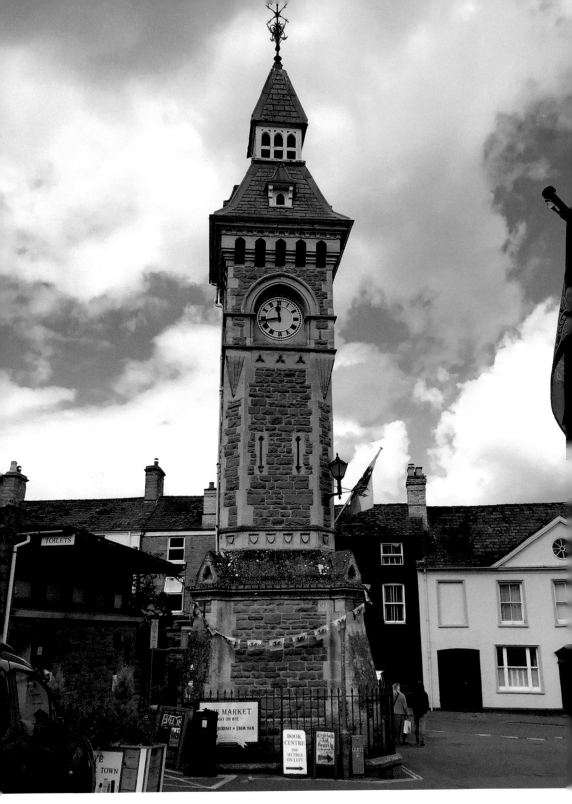

Hay clock tower. (Valerie Dean)

But at the beginning of February 1921 Mrs Armstrong fell ill again, after eating Sunday lunch. Her condition continued to deteriorate and she died on 22 February. After the funeral, Major Armstrong was described as depressed but he rallied after getting a letter of sympathy from Marion Gale, an old family friend. They subsequently met several times and, by May, he had asked Mrs Gale, a widow, to marry him.

In the summer, Armstrong and Martin became involved in a complex legal dispute over an estate in Wales. Tempers frayed and discussions became quite bitter, as they often can in a small market town. Martin was a little surprised to be invited to tea at Mayfield in October but the event passed off cordially. However, in the evening, Martin was taken ill with severe stomach pains. His father-in-law, one of two local chemists (Armstrong had aided the second one to set up his business), became convinced that Martin had been poisoned. He also recalled a box of chocolates that had been delivered anonymously to the Martins the previous month and that Martin's sister-in-law had become ill after eating one.

Dr Hincks, the local doctor, was persuaded to take a sample of urine from Martin as well as the remaining chocolates and sent them to the Home Office for testing. Traces of arsenic were found in both and, after a two-month investigation by the police, Major Armstrong was arrested for attempted murder. Then Dr Hincks, previously a friend of Armstrong, started thinking about the death of Katherine Armstrong. At the beginning of 1922 he had persuaded the police to exhume her body. The postmortem was carried out by Sir Bernard Spilsbury, the senior Home Office pathologist. Arsenic was found in every part of Katherine's body. Now Armstrong was sent for trial for the murder of his wife as well as the attempted murder of Martin.

The trial opened at Hereford Shire Hall on 3 April 1922. The evidence seemed damning and Armstrong's case was not helped by the behaviour of the trial judge, seventy-three-year-old Mr Justice Darling, who had been a judge for forty-seven years. He made no secret of where his feelings lay, praising the way the prosecution case was being presented and belittling that of the defence. Armstrong's well-documented buying of arsenic (he claimed for gardening purposes), including a small packet in his pocket when he was arrested, was highlighted and other innocent ways that Mrs Armstrong might have come into contact with the poison were dismissed. In his summing up he strongly recommended the jury accept the case that Katherine Armstrong had been slowly poisoned by her husband. After only forty minutes deliberation the jury returned. The verdict was guilty; there was only one possible sentence, death.

The public were angry. Most people believed in Armstrong's innocence. Despite this an appeal failed and Armstrong was hanged at Gloucester gaol on 31 May. The warders who watched him described him as a man of courage and courtesy, mostly concerned about the future of his children and always professing his innocence. Because of his slight build the hangman, John Ellis, had to arrange an unusually long drop of 8 feet to make sure the neck was broken.

Above: St Mary's Church, Cusop. (David Phelps)

Below: St Mary's churchyard, where the exhumation took place. (David Phelps)

Was Armstrong guilty? Under modern forensic conditions it is unlikely that he would have been condemned, much of the evidence against him being circumstantial. It is difficult to think of a motive. The marriage seemed to be happy and Armstrong had not touched the bequest his wife had left him. The prosecution could present no evidence that the relationship with Marion Gale was anything but the friendship of two lonely people. Arsenic was a much more common feature of the domestic environment than it is now and some of the patent medicines Mrs Armstrong used contained it. Just before her death she was considered suicidal by the doctor and nurse looking after her because of the pain she was in. If Armstrong was guilty, why did he not have her body cremated?

What of Davies the chemist and solicitor Martin? Davies, hearing rumours that it was suicide and at risk of being blamed for supplying it, might have done everything he could to shift the blame on to Armstrong. His son-in-law, Oswald Martin, stood to gain most. With Armstrong out of the way, he, the only solicitor in the town, was likely to thrive. Who keeps a box of chocolates that made people ill? Unless it had already been planned that it might come in useful later. When Martin fell ill after taking tea with Major Armstrong, it was only his word that his sickness had been caused by his rival.

The court of public opinion decided against Davies and Martin and they were forced to leave Hay not long after Armstrong's execution. Major Armstrong remains the only British solicitor hanged for murder.

12. THE BUTLER DID IT

Burghill Court. (David Phelps)

Real-life murders are rarely as convoluted as TV dramas would have us believe but occasionally crime cliches become reality.

In September 1926 Burghill Court, the big house of the village 6 miles northwest of Hereford, was occupied by two elderly spinsters, Miss Ella and Miss May Woodhouse. The house was owned by their brother, but he had allowed his sisters to stay in the family home and, under the terms of their father's will, the two women had been left very comfortably off. They did good works around the village, as befitted their position, but were also considered overly pious and arrogant.

On 7 September at around 10 a.m., their cousin Ernest Jackson, who was staying at the house at the time, heard two gunshots, not outside but clearly inside the house. He rushed downstairs and was confronted by the sight of Miss Ella lying in the passageway to the kitchen. She had suffered a shotgun wound to the head and was clearly beyond help. Further along the passageway he found Miss May with a fatal wound to her chest. The cook and other inside servants quickly arrived and Jackson went for help. The coachman, John Towne, dashed into the house and cradled Miss May in his arms until she died.

Given the social status of the victims, Superintendent Weaver attended the scene. Soon it became clear that one obvious absence was that of the butler, Charles Houghton. Jackson recalled seeing him rushing to his room while Jackson was hurrying down the stairs to investigate the shots. Weaver, who had visited the court in a social capacity several times and therefore knew Houghton, went to the butler's room and demanded Houghton open the door. It opened a crack and then slammed shut again. With further banging on the door, it opened again. Houghton came out, bleeding from wounds to his throat. Dr Shaw, the local doctor attending the scene, found them to be superficial.

Houghton was inevitably charged with the murder of the two sisters. He appeared at the Hereford Assizes of 5 November. His lack of funds meant that he was entitled to legal aid.

During the trial it became clear that – another cliché in the case – the butler had a drink problem. For some months he had been able to conceal it, remaining efficient and courteous in his job, but by the late summer of 1922, this was no longer possible. He was often missing from his duties, including opening the door to visitors. While serving at dinner on 31 August he dropped a dish of vegetables and it was clear to all present that he was drunk.

The Misses Woodhouse had been loath to dismiss Houghton. He had been with the family for over twenty years, working his way up from footman. Aged forty-five, it would have been difficult for him to find another place of employment. But they must have decided that there was no other course of action, although they waited until the weekend of 5–6 September when they would have house guests who might provide moral support. On Sunday Houghton was called before the sisters and told of their decision. He was devastated, having no inkling that such a thing was going to happen. Although given the option of transferring to their brother's establishment in Yorkshire, this he refused, feeling too old to uproot himself from all his acquaintances. Originally only given one day's notice with a month's pay in lieu of notice, it was eventually agreed that he could stay until the end of the week. He went to his room and refused to come out to carry out his duties while the shocking news spread around the servants.

But the following morning he seemed perfectly normal, if subdued, serving breakfast and attending morning prayers as usual just before nine o'clock.

The murder weapon belonged to Ernest Jackson, which he used for shooting on the estate when he came down to visit. It was kept in the butler's pantry and

Houghton, a trusted employee, had been allowed to use it on other occasions. One of the maids, Beatrice Cotterell, gave evidence that, when she heard the first shot, her first thought was that Houghton had shot himself.

In his defence his barrister provided evidence that Houghton had suffered from epilepsy as a child. Expert witnesses were called who thought it quite possible that the shock of the dismissal had brought on another attack and Houghton was technically insane at the time of the murders. It would therefore not be right to hang him. The jury disagreed, finding Houghton guilty of murder and the grim sentence of death was announced.

After what must have been an excruciating delay while an appeal was lodged and failed, Charles Houghton was hanged in Gloucester gaol on 4 December by the state hangman, Thomas Pierrepoint. In accordance with the law an inquest had to be held into his death, at which the coroner, James Waghorne, sought to calm any fears that the people of Gloucester might feel because of the number of hangings taking place there. He pointed out that this was due to the closing of the prisons of Worcester and Herefordshire rather than any innate criminality in Gloucestershire.

St Mary's, Burghill. (David Phelps)

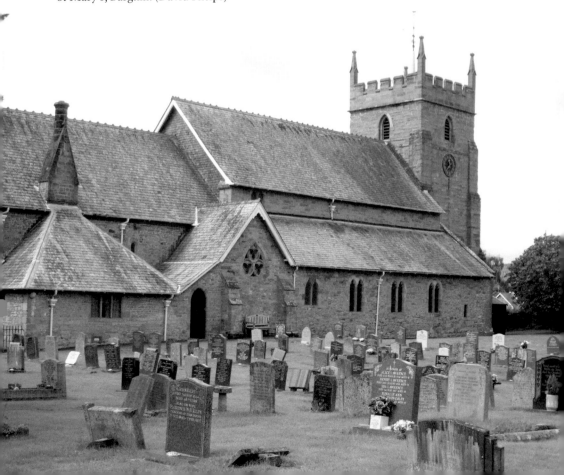

The Woodhouse sisters' grave, St Mary's. (David Phelps)

13. THE HUNTER'S HALL TRAGEDY

Lea. (Valerie Dean)

The small village of Lea, to the southwest of Ross, is as quiet a place as you would hope a Herefordshire village could be. But, at 7 p.m. on the evening of 9 January 1932, PC Matthews, the local constable, got a summons to go immediately to Hunter's Hall, a detached house in the village.

It was home at the time to Edith Dampier, a widow aged thirty-six. Her husband had been a respected farmer and her father a Ross auctioneer. Left with a young son to look after, she was regarded locally as a rather tragic but somewhat strange figure.

When Edith Dampier opened the door to the constable, her first words were, 'The man who works here has shot himself. He is in the armchair in the kitchen.'

There Matthews found a man he would later discover to be George Parry, a thirty-one-year-old handyman, sitting in a chair, legs stretched out, feet together, knees apart, one hand on each thigh. His head was dropped forward and leaning slightly to the right. Between his feet and resting on the inside of his left knee was a double-barrelled shotgun, the stock against his left foot. There was a 2-inch wound on the right of his neck.

Matthews examined the shotgun and found that one barrel had been fired; the other was clean. Mrs Dampier informed him that Parry had two cartridges. Matthews made a quick search of Parry but did not find the other cartridge.

'Here it is.' Mrs Dampier took hold of the left-hand pocket of Parry's jacket. Sure enough, that is where Matthews found it.

While the body was being removed and the scene examined Matthews took Mrs Dampier to Ross police station to make a statement. She told him that Parry had bought the shotgun cartridges at around 4 p.m. that afternoon from Lea post office for the purpose of killing rats, which were becoming a problem at Hunter's Hall.

In the early evening they had both been in the kitchen, Parry trying to fit the cartridges into the gun as he was not sure they were the right type. She told him to be careful as he was not used to guns but he assured her that it was perfectly all right as it had 'a safety thing'. She then went upstairs and then heard the gunshot. Rushing down she saw the sight that Matthews had seen and called the police.

The statement complete, she was about to leave when she asked, 'Shan't I have to go to prison?'

'What makes you say that?'

'I heard that, if a man is killed in your house you have to go to prison.'

Matthews assured her that that was not the case but, once Mrs Dampier had left, he had to admit that there were some troubling aspects of the case. Parry lived at Yew Tree Cottage, near Mitcheldean Road station. He was a simple soul but always had a smile on his face, not really the sort of person to commit suicide but also someone whom it would be quite reckless to leave alone with a loaded shotgun. He decided to consult his superiors.

When Parry's body was examined it became clear that this was not suicide. The fatal shot had been delivered from around 30 inches away. Also, the safety catch was still on and could not have discharged accidentally. Someone other than Parry had pulled the trigger. As the only other person in the house Mrs Dampier was arrested for murder and appeared at Hereford Assizes.

The trial started on 12 February 1932. Mrs Dampier was represented by Norman Birkett KC, regarded as the leading barrister of his day. She pleaded not guilty but it soon became clear that Birkett's defence would be that Mrs Dampier did indeed pull the trigger but there were terrible mitigating circumstances.

First Sir Bernard Spilsbury, the renowned Home Office forensic expert, confirmed that his view was that it was impossible for Parry's wound to be self-inflicted as, given the nature of the injury, the gun must have been horizontal when it was fired. Then Robert Churchill, the London gunmaker, confirmed that it had been fired from some distance away.

Lea village store. Once it was possible to easily buy shotgun cartridges. (Valerie Dean)

The defence called Dr Dunlop, Mrs Dampier's registered doctor for around five years. He had been very concerned about Mrs Dampier's state of mind for some time. She had threatened to shoot her son Robbie and then drown herself. She had also seen and talked to her dead husband, even though he had been dead for some years. Subsequent testimony elicited the reason for her torment. She had feared she had transmitted 'a complaint' to her son, which had left him blind in one eye and would eventually lead to a terrible death. Although it was not stated in open court, people of the time would realise that this was syphilis and that she had been infected by her husband.

Further medical experts were called, all giving the opinion that Mrs Dampier was medically insane and had been at the time of the murder.

As the trial concluded the prosecuting barrister declined to make a final address to the jury, allowing Norman Birkett to set out his case for a verdict of 'guilty but insane'. He made it clear that Parry was in no way responsible for her appalling medical condition and his death was purposeless. 'If, instead of Parry, the other man who had brought trouble to Mrs Dampier had been shot there would have been abundant motive for Mrs Dampier, wishing to rid the world of him,' he concluded.

After hearing the evidence and the judge's summing up the jury felt no need to retire but, after a swift consultation, duly brought in the verdict: 'guilty but insane'. She was sentenced to be detained during His Majesty's pleasure, a tragic example of the misery that can exist in idyllic rural surroundings.

14. DEATH OF A SHOPKEEPER

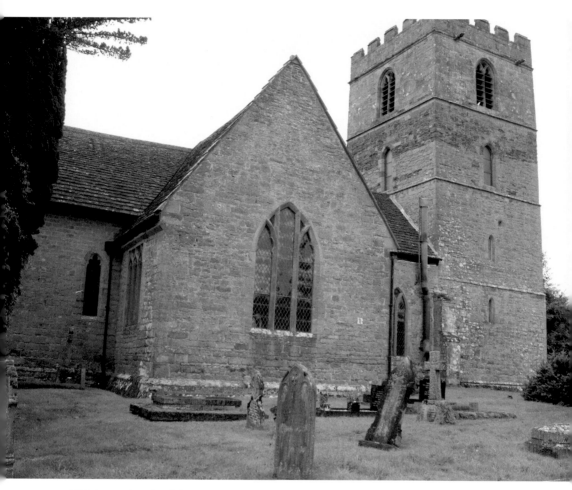

All Saints' Church, Clehonger. (David Phelps)

To those people returning from service in the Second World War and those at home suffering wartime restrictions, the little village of Clehonger, to the west of Hereford, must have felt like the epitome of what they had been fighting for. Many restrictions might be still in place but there was a general feeling that things would improve with the coming of the welfare state and, above all, peace.

That optimism would be shattered on 14 March 1952.

Maria Hill, aged seventy-four, kept a shop in the front room of the small bungalow she had lived in since being widowed twenty years before. It provided

the village with the small necessities of life and spared them having to take the bus into Hereford. She was a respected member of the community and was commonly known as Nanna Hill.

At around midday on 14 March, Mrs Harris, one of Nanna Hill's regular customers, called at the Bungalow Stores to do her shopping. The door was unlocked, but, on opening the door, Mrs Harris was surprised that the little bell attached to the door which normally alerted Nanna to a customer's arrival did not ring. She saw that it had become unscrewed and, being neighbourly, screwed it back in. Though the bell now rang Mrs Hill did not come to serve her. Thinking that the shopkeeper must have popped out on her own errands, she left, returning in the early afternoon.

But the same thing happened. The bell rang but Mrs Hill did not appear. Mrs Harris walked through the shop into Mrs Hill's private parlour, hoping she would not mind. But a sight of horror greeted her. Mrs Hill was lying motionless on the floor near the fireplace. Thinking the old lady had been taken ill, Mrs Harris rushed over to her but saw that her head and face had been badly burnt and there was a great deal of blood from what looked like stab wounds. She rushed to a neighbour whom she knew had a telephone and the police were called.

The village constable, PC Allman, arrived in half an hour and it was clear to him that Mrs Hill had been the victim of foul play. He summoned reinforcements from Herefordshire Constabulary, who in turn were assisted by Scotland Yard.

The postmortem was carried out by Prof. Webster of Birmingham University, a highly respected forensic examiner. He found that Mrs Hill had been strangled, enough to render her unconscious but not to kill her. She had then been attacked with an axe. It was not clear whether she had fallen forward into the fire or whether the burns were caused by charred pieces of that week's *Radio Times* which were found around the body, which might have been an attempt by the attacker to burn down the bungalow. Mrs Hill was probably still alive but unconscious when she suffered those burns. Her death had been caused by loss of blood on the evening of 13 March.

The last people to see Mrs Hill alive, other than the murderer, were questioned. Mr Preece, a local man, had gone in to buy sweets at around 3.30 p.m. on 13 March and said that Mrs Hill behaved completely normally. At around 7.30 p.m. Ann Smith had called at the shop, also to buy sweets. The door had been locked but this was Mrs Hill's normal custom after dark. Mrs Hill had come to the door in response to Ann Smith's knocking and they had chatted for around fifteen minutes before she left. Passers-by later in the evening remembered that a light was on in the shop, at least until 10 p.m.

Mrs Harris's son, Bonar George Hill, who worked at a club in Malvern, arrived at around 9 p.m. on the 14th. He had had no notification of his mother's death and was terribly upset when he found the bungalow under police guard and was informed that his mother's body still lay inside, the victim of a brutal murder. He was later taken to Hereford County Hospital where he was able to formally identify his mother's body.

He told the police that the average weekly takings from the shop were around £7. This and her old age pension were enough for her to live on. A search led him to believe that around £60 had gone missing, although the police found money still in the till and £1 14s 6p hidden in a tea caddy. Her savings passbook with three pound notes tucked inside was also found, although the envelope that it was in was heavily bloodstained. Missing were her account books, the rest of the *Radio Times* and her pyjama trousers.

The horrible murder of a much-loved village resident meant that the police threw all their resources into finding Mrs Hill's killer. Despite this no suspect was identified, although over 2,000 people were interviewed, including a woman who had been in Hereford County Hospital at the time of the murder and had had a nightmare on that fateful night of an elderly woman being battered by a man in a small shop. So vivid was the dream that the woman was able to give a description to police but it did not tie in with any potential suspects. Three years after the murder Detective Inspector Weaver gave a talk to Ross Rotary Club in which he hinted that the police knew who the murderer was but could not find enough evidence for an arrest to be made. This is still the case and the crime remains unsolved.

15. THE DISAPPEARANCE OF DEREK SAVILLE

Derek Saville.
(*Hereford Times*)

On the night of 7 December 1954 Derek Saville, a bus mechanic with Yeomans coaches, and his girlfriend of around three months, Ivy Wood, a secretary in Hereford, had a quiet drink together in the Plough Inn in Canon Pyon. Derek was well known in the pub, being a member of the darts team. Then he walked Ivy back to her home, Corner House. It was a cold evening, with snow on the ground. At 11.30 p.m. Derek kissed Ivy and said, 'Goodnight dear, see you tomorrow,' and set off to his lodgings at Bush Bank, just a mile away. Derek Saville was never seen again.

When his landlady found that his bed had not been slept in she was not greatly concerned, assuming that he had gone to his widowed mothers in Preston Cross, near Ledbury. Ivy was a little surprised when Derek did not call for her that evening but thought he might have got overtime at the garage.

Time passed and Derek still did not make an appearance and the two women began to be concerned. Eventually the police were contacted and when they too could find no trace of the missing man, a major investigation was set underway.

Above: The former Plough Inn.
(David Phelps)

Left: Derek Saville set off along a snowy lane and was never seen again.
(David Phelps)

Detective Inspector Ron Weaver led the investigation and his hunch was that they were looking at a murder. Immediate suspicion fell on Ivy's ex-boyfriend, with jealousy being a motive. But the young man, who lived in the neighbouring village of Tillington, maintained his innocence, saying that it was he who had finished with Ivy and he now had a new girlfriend. He had seen Derek early in the evening of his disappearance but had then gone home and could produce witnesses to that effect.

Derek's bicycle was soon found, propped up against Canon Pyon parish hall, with a puncture in its front tyre. It was presumed he had collected it from the garage where he had left it but, finding the puncture, had decided to leave it to be collected later and to walk home.

It soon became clear that Derek was, in the language of the time, something of a ladies' man. No fewer than five women came forward during the investigation to say that they had been former girlfriends. But all maintained that he had been a perfect gentleman throughout their time together and they could think of no one who had been angered by their relationship. With his good physique, always neat appearance, steady job and a happy-go-lucky attitude, he was exactly what many girls were looking for in a boyfriend.

The Nag's Head, Canon Pyon. (David Phelps)

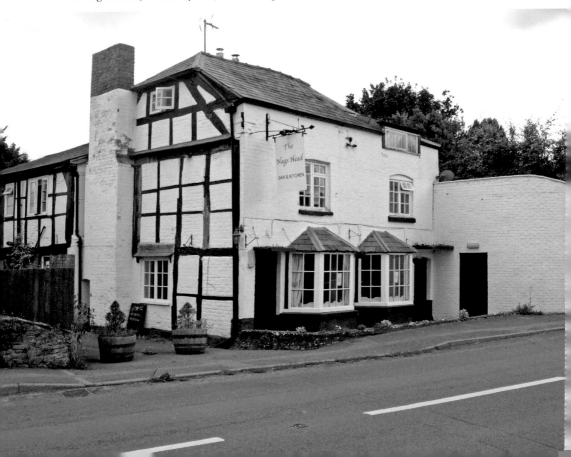

The mystery deepened when Ivy informed the police that Derek had told her that, back in October, he had been walking home when he had heard a rustling in the hedge behind him. Turning, he was confronted by a man with him arm raised but, when Derek dropped his bicycle and prepared to defend himself, the man ran off. The landlord of the Nag's Head, the other pub in the village, confirmed that there had been reports about that time of a man seen loitering about the village and hiding behind trees. Despite police pleas no one came forward with further information. Derek's mother said that, at their last meeting, he had told her, 'Mum, a man is going to get me. He has threatened to run me down with his car. If you don't hear from me again, you'll know that he has got me.'

An extensive search of the surrounding area got underway, involving two divisions of police, soldiers from nearby Hereford and a large contingent of villagers, anxious to find out what had happened to this popular man. More ominously there were also dog teams, skilled in locating dead bodies. Despite all this, no trace of Derek Saville was found. Some buttons were discovered but they had no link to the missing man. A patch of blood caused momentary excitement but proved to be non-human. Inspector Weaver began to examine the possibility that, given the threats against him, Derek Saville had found Canon Pyon too hot and had decided to make a life for himself somewhere else.

Christmas was a grim affair in the village of Canon Pyon that year. People could not escape the feeling that, as they gathered for the festivities, there might be a murderer amongst them.

Time moved on. The police could find no further leads; Derek Saville's disappearance was overtaken by other events in the national conscience. But in the village of Canon Pyon it remained an unanswered question, what had happened to their friend?

Then, in 2007, there was a new development. A man, now living in Perth, Australia, but who had lived in Canon Pyon as a child and had been about seven at the time of Derek's disappearance, contacted police while he was back in the UK on holiday. He said that, about that time, he had seen his father and five other men digging what looked like a makeshift grave one night. His father had died earlier that year and he now felt it was the right time to come forward and try to solve the mystery. Local people recalled that unexplained lights had been seen in that area a couple of nights after Saville had gone missing. Extensive searches and excavations were made but no trace of a body was found.

To this day what happened to Derek Saville remains a mystery.

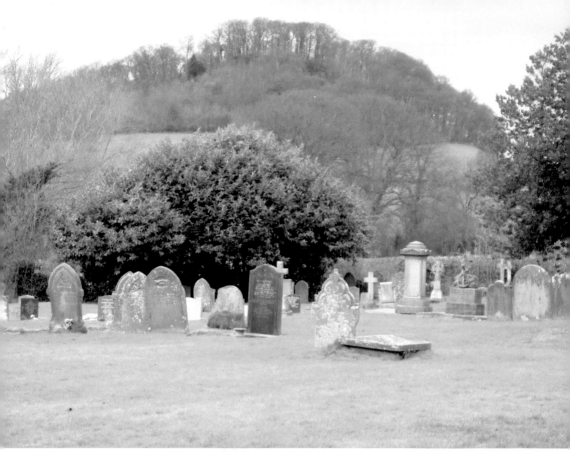
Is Derek Saville's body buried in the countryside around Canon Pyon? (David Phelps)

16. AN EYE FOR AN EYE

On the evening of 18 November 1968 Terence Davis, who lived at Hopton Heath in north Herefordshire, saw a white Austin car badly parked at the entrance to a driveway. Sensing that there might be a problem Mr Davis went to investigate and found a badly injured man in the driver's seat but slumped over into the passenger's side. Despite extensive head wounds Mr Davis recognised him as Dr Beach, the local doctor. A passing motorist, Mrs Disley, stopped to help and noticed a strong smell of whisky in the car. Dr Beach died before any other help could be sought.

The entrance to Heath House, where the dying doctor was found. (David Phelps)

It was clearly a matter for the police. They quickly identified the car as one belonging to a fifty-year-old hairdresser in nearby Leintwardine, Arthur Prime, who had only bought the car three days before. When they attended his address in Watling Street, Leintwardine, the following day they could get no response, although the windows were steamed up. They decided to force entry accompanied by two police dogs. They found Prime in the bedroom unresponsive and with a shotgun by his side. In the heat of the moment the senior police officer, Detective Chief Superintendent Booth, grabbed the gun but did so clumsily. The gun discharged, killing one of the dogs. But even this tremendous noise failed to rouse Prime. An ambulance was called and he was rushed to hospital with a suspected overdose.

His life was saved and, by the end of November he was judged fit to be charged with the murder of Dr Beach and he appeared at Hereford Assizes in February 1969. He pleaded not guilty. It soon became clear that there was bad blood between Beach and Prime, the latter blaming the doctor for the death of his wife, Irene, the previous year. The death had been sudden and Arthur Prime had naturally been distraught, refusing to let Dr Beach enter the house. After the

Watling Street, Leintwardine. (David Phelps)

local constable, PC Jones, intervened, Prime was persuaded to allow the doctor in but, after he had left, Prime once again became agitated and intimated to the constable that he held Dr Beach responsible for his wife's death. 'An eye for an eye, a tooth for a tooth and a life for a life,' were the words the constable remembered him muttering. Prime was further incensed by being prevented from being present at the post-mortem and the conclusion, that his wife had died from natural causes, convinced him that the local doctors were in league together to cover up malpractice.

Over the next few months Prime seemed to calm down and made no further accusations. He even began courting Hazel Latimer, a shop assistant from Leintwardine. By October 1968 they were engaged.

But the hairdressing business was not going well. A former employee, who Prime had sacked, was setting up her own salon in Leintwardine. Prime took this as a direct attack on his wife's memory. The stress seems to have been the fateful cause of what happened next.

St Mary Magdalene,
Leintwardine.
(David Phelps)

Prime purchased the white Austin, although he already owned another car. He also bought a double-barrelled shotgun that had been advertised in the Hereford Times. He then wrote letters to his fiancé, calling off the engagement and to his mother, saying that he had had enough and could not see any future in living. His last letter was to the Herefordshire Constabulary, complaining that they had failed to take his complaints seriously and although not of unsound mind, he was not prepared to let his wife's business be destroyed, adding, 'I'm sorry for the scribble, only I am in a hurry to join my wife.'

That fateful night in November 1968, Dr Beach was holding his usual evening surgery. He was interrupted by a telephone call at around 7.15 p.m. which called him out to what he believed was a medical emergency. He never returned.

Prime's defence team argued that he had behaved perfectly normally. Of course a man was distressed at the time by the sudden death of his wife. But Leintwardine was a small village and, in the intervening months, Dr Beach and Prime must have encountered each other on multiple occasions since then but he had not made a scene. Several witnesses came forward to say that Prime had discussed his wife's death quite rationally in the months since her passing and they had not heard him utter any warnings. The letters Prime had written included no threats to the doctor, only that he was at the end of his tether because of problems with the business. The mysterious call to the surgery was traced to a call box at Bedstone. The call-handler clearly recalled that it had been made by both a man and a woman. Although there was a strong smell of alcohol at the murder scene, neither Dr Beach nor Prime had any trace in their bloodstream. Despite the doctor's gruesome injuries, no blood splatter was found on the clothes Prime had been wearing that evening.

Despite these pleas the jury took just ninety minutes to find Prime guilty. Prime interrupted the judge's summing-up several times, incensed that he had not been called to give evidence on his own behalf. He was sentenced to life imprisonment. He died, still in prison, in 1995.

17. MURDER IN SUBURBIA

On the Sunday afternoon of 23 January 1977 Margaret Davies's sixteen-year-old daughter, Lesley, went round to visit her mother, who lived in Whitten Way, Tupsley, on the outskirts of Hereford. She let herself in with her key but got no answer when she called out. She was also surprised to find the curtains of the living room still drawn. She started to fear the worst. Her mother was a heavy drinker and she suspected that her mother might have gone on a bender on Saturday evening. She cautiously approached her mother's bedroom but the sight that greeted her there was more horrible than even she had expected.

Her mother was dead, lying on her back on the bed. She was fully clothed but her top had been pulled up exposing her left breast. She had been stabbed and gagged and her hands and feet were tied together with one continuous piece of string.

Whittern Way. (David Phelps)

The police arrived quickly. They found the rear door locked from the inside and no sign of forced entry. They already knew Margaret Davies, partly because of her drinking but also because of a tempestuous relationship she had with a coach driver, Harold 'Ginger' Williams. The pair had met at the end of 1975 when Margaret was forty and Williams four years older. Williams moved into Whittern Way in early 1976 but, in January 1977, he was charged with assault on Davies and pleaded guilty. It was a condition of his bail that he move out of the house he shared with Davies and live with his parents elsewhere in the city. He was to have no contact with Davies.

Naturally Williams was the first person to whom they wanted to talk, and they found him at his parents' address later that afternoon. He immediately volunteered that he had not seen Davies since the ban although she had telephoned him at work several times but he wanted nothing more to do with her. He assumed she was after money. The police officer believed that Williams looked quite shocked when told Davies was dead. He put his head in his hands and started to cry. 'How did she die? Was she on the bed?'

'Why?'

The former Hereford police station where George Williams was repeatedly questioned. (David Phelps)

'Because her ruddy doctor keeps giving her pills. I thought it would do for her in the end. She was a lovely woman when sober but a bitch when drunk. One time when she was on the booze she threatened to go and desecrate my son's grave.'

Williams was asked to come down to the police station in Gaol Street, which he willingly did and continued to answer questions. In the end he was interviewed a total of nineteen times before the police decided to charge him with Davies's murder in April. At the trial Williams pleaded not guilty.

The pathologist, Dr Dawson, believed that death had occurred sometime between Friday evening and Saturday morning because, when he examined the body, rigor mortis had set in and there were some signs of putrefaction. Death was due to strangulation by ligature and the stab wounds had been inflicted after death, one with such force that it had divided the third rib. There were two types of wound, one made with a knife, the other small puncture wounds. A duster had been stuffed in her mouth as a gag.

A neighbour testified that she had met Mrs Davies coming out of the local chip shop at around 9.30 p.m. on the Friday evening. A sixteen-year-old girl, Dawn Mapp, who also lived in the area, had also come forward. Her original statement said that she had last seen Davies on Saturday afternoon but later changed her statement, saying she had been confused and it was Friday afternoon.

Williams's employer said that he had arrived at the garage at around 7.45 a.m. on the Saturday morning and found Williams's car in the yard with the engine running and Williams asleep inside. He tapped on the window, waking Williams, who apologised and said he was just taking a quick nap.

When police searched Williams's car they found Davies's address book as well as some of her personal papers similar to ones they had found scattered in the hall at the murder scene. They also found an abandoned car that Williams kept at the garage where he worked. A table knife was found in the glove compartment and a bag in the boot containing fishing equipment and a bent knitting needle. No blood was found on the knife or the knitting needle. The case attracted national attention when the comic actor Terry-Thomas was called for the defence. He was best known for playing cads in blazers but by that time was also the presenter of *Angling Today*, a fishing programme on TV. He explained that a bent knitting needle was a common implement with which to dispatch eels.

The knots used to tie up Mrs Davies were of a kind commonly used by hop-pickers and it was pointed out by the prosecution that Williams had worked as a hop-picker in the past.

The jury took six hours of deliberation before they reached a verdict of guilty, and Williams was sentenced to life imprisonment. Despite this he always maintained his innocence, even though he thereby lost any chance of being given parole.

Leave to appeal was only granted in 2003, even though Williams had died in 2000. Lawyers acting for Williams cast doubt on Dr Dawson's testimony as to time of death, he himself having admitted that exact time of death, because of the length of time before he examined the body, could not be fully determined. Dawn Mapp said that she had been coerced by the police into making the second statement altering the time she had seen Mrs Davies. Another neighbour, Mrs Hall, also now came forward to say that she had seen Davies alive on Saturday morning. The police had also not made any enquiries about a strange man gazing fixedly at Davies's house a few days before the murder.

Despite the appeal judges agreeing that the evidence against Williams was circumstantial, they found there was a great deal of it and they therefore refused the appeal.

18. THE FIFTH SHERRY GLASS

There is a popular misconception that lightening does not strike twice in the same spot. This is untrue, just very unlikely. In 1987 nineteen years after the mortally wounded Dr Beach was found outside the driveway to Heath House, Leintwardine, the body of the architect Simon Dale was found in the kitchen of the same house.

Dale was a larger-than-life character. Sixty-eight at the time of his death, tall, bald and with a booming voice but with failing eyesight, he tended to dominate conversation when his interest was aroused – and he had many interests. As well as architecture he was interested in optics, medicine, archaeology and history. He was convinced that Heath House might be the site of an ancient capital of Powys and therefore would have strong links to one of the warlords who could be identified as King Arthur. This is not as fanciful as it might sound. Though historians doubt the existence of one Arthur, they have come round to the idea that the name might represent several chieftains who flourished after the Romans left, especially in the west of the country. He had published articles on this theme in the *British Archaeological Monthly*.

Despite his poor eyesight, Simon Dale was fiercely independent. With the aid of thick spectacles he was able to cook for himself and organized lifts to Shrewsbury or Leominster, where he liked to challenge the District Planning Office on some issue where he thought he knew better. He was aided by a small group of loyal friends who paid frequent visits and helped him type manuscripts and deal with correspondence.

Simon Dale.
(*Hereford Times*)

One such friend was Giselle Wall. On Sunday 13 September she had finished some typing and was surprised when she telephoned Dale not to get an answer. She decided to drive to Heath House anyway, arriving in the late afternoon. She found the back door unlocked and, having received no response to her call, went in. The light was still on in the passage, her first inkling that something was wrong. Although it was a warm day the heat in the house was unusually intense. When she entered the kitchen she was confronted by the body of Simon Dale, lying on his back with a pool of blood around his head.

She drove to Dale's nearest neighbour, around a quarter of a mile away, and an ambulance was called. The ambulance men, on arriving in the kitchen, saw that the oven was still on, generating an unbearable level of heat. They also saw that there were signs of a violent struggle. They called the police.

Detective Constable Daniels, from Leominster CID, quickly established that Dale must have been disturbed while preparing a meal—the blackened remains of a toad in the hole were in the oven and vegetables were on the kitchen table waiting to be prepared. Of special interest to the detective were five sherry glasses near the sink, one cracked, three with traces of sherry and one still half full. It was unlikely that this was a simple robbery. There was no sign of forced entry and Dale still had his wallet containing 25£ in his back pocket.

Heath House. (David Phelps)

One of the first people of interest was Dale's ex-wife, Susan, then living in a small cottage in nearby Docklow. There was a bitter dispute between the two over possession of Heath House. After the divorce it had been agreed that the house should be sold and the proceeds divided, Dale to be allowed to stay in the house until the sale. Inevitably Dale had been able to deter any would-be buyers.

Susan was the great-great-granddaughter of William Wilberforce. She had been a debutante in the 1950s and had met Dale, fifteen years her senior, at a London dinner party. Attracted by his unconventional manner she married him in 1957. As children came along they decided to move out of London and discovered the semi-derelict Heath House. They bought it with the intention that, with Susan's money and Simon's architectural skills, they would restore it. For the first few years they were happy but, as Dale's eyesight deteriorated, he became depressed. Bringing up by now five children in isolation, the lack of money and her husband's increasing violence towards her persuaded her to leave in 1972 and start divorce proceedings.

By the time of the murder she had remarried, to Baron Michael de Stempel, a Russian aristocrat. They had known each other during Susan's debutante season. Later his own defence counsel would describe him as 'a congenital liar … a monumental snob and a man without courage'. But, having married him, Susan could now call herself Baroness de Stempel.

The first thing that struck the police when they visited the little cottage in Docklow, which Susan had grandly renamed Forrester's Hall, was the surprisingly large amount of expensive furniture crammed into the small cottage. The second was the lack of emotion she showed on being told of her ex-husband's murder. She would later ascribe this sangfroid, which she exhibited throughout the coming months, to her education, being trained not to show emotion. To the police it was a sign of guilt.

A postmortem indicated that Simon Dale had died on Friday 11 September. Susan admitted that she and two of her children had been in the grounds that afternoon, trying to tidy them up for potential buyers. Two of Simon Dale's helpers, Ben Scott and Susan Evans, confirmed this, having been to see Dale that afternoon, but said they had been treated to a diatribe against Simon by the Baroness, that he was mad and the house full of fleas.

Although no forensic evidence could be found linking her to the crime, the police felt they had enough to convict her and Susan de Stempel was charged with her ex-husband's murder. She was sent for trial at Worcester Crown Court in July 1989, an unusually hot period when court officials in their legal robes suffered quite a bit. The Baroness remained cool and disdainful throughout, at one point removing her shoes and watching proceedings in stockinged feet.

The prosecution made much of her strange behaviour on the night Simon Dale was murdered and her desperation to get Simon Dale out of the house. However, no forensic evidence had been found to link Susan de Stempel to the murder.

For the defence much was made of the five sherry glasses. Three were probably drunk from by Dale and his visitors that evening, the fourth, being cracked, had probably been discarded but who had drunk from the fifth, half empty glass? Ben Scott had stated that Simon had mentioned expecting another visitor later. Frustratingly he did not comment on who that might be. Given their relationship it was unlikely Dale would have opened the door to his ex-wife or invited her in.

After just four hours the jury returned, with a not guilty verdict. This was greeted with cheers from the public gallery and a bouquet was thrown at the Baroness's feet. But her legal troubles were not over.

The police had been concerned about the fine furniture discovered in Forrester's Hall. They discovered that it came from Susan's aunt, Lady Illingworth, known in the family as Aunt Puss because of her love of cats. Susan had persuaded her eighty-two-year-old aunt to leave her large flat in Kensington for a holiday in Docklow. The holiday lasted ten months. After that time the once rich widow, suffering from dementia, became a resident in a nursing home in Hereford, her fortune having mysteriously disappeared.

Susan, two of her children, Marcus and Sophia, and Michael de Stempel were charged with theft, fraud and forgery. This time she and the rest of the family pleaded guilty. Susan was sentenced to seven years, Marcus eighteen months, Sophia thirty months and de Stempel four years.

No one else has ever been charged with Simon Dale's murder. An unsolved murder is never officially closed but the police put no extra resources into reopening the case and finding the drinker of the fifth sherry glass. They had brought a suspect to trial. It was up to the members of an English jury to make up their minds about it.

19. THE HEREFORDSHIRE HOARD

Metal detectorists, as well as following a hobby that gets them out into the fresh air, provide a valuable public service. By searching forgotten fields, they can bring to light finds and archaeological sites of which archaeologists were not aware, aiding our understanding of the past. A short while ago the accepted site of the Battle of Bosworth was moved several miles from where academics said it had been fought to the place where detectorists had found a great deal of battle debris, the place where local legend had always said it had taken place.

Because of this valuable service they are quite rightly rewarded for their work. Under the Treasure Act any exceptional finds are valued and the money paid, half to the landowner, half to the detectorist.

Unfortunately, there is a dark side to the hobby: those who do not seek permission before they search, who go out under cover of darkness and do not report any finds but try to sell them on the black market, the hated nighthawks.

In June 2015 Herefordshire had the misfortune of two such nighthawks finding the greatest archaeological treasure in the county. The two men, a warehouseman and a school caretaker from South Wales, were experienced detectorists. They were searching an area near Eye in north Herefordshire with the exciting name of King's Hall Hill when their equipment started to beep. They made a cursory dig – there is always the expectation of a ring pull – but this time their torches disclosed the unmistakable glint of gold.

Further digging uncovered a mass of ancient coins, a gold serpent's head bangle, a magnificent gold ring and an intricate crystal pendant. In the heat of the discovery one of the men took a photo on his mobile phone. Then they made their greatest mistake: continuing digging up the finds and taking them away rather than what detectorists are supposed to do with a find of this nature, reporting it to the authorities so that the hoard's context and full story could be preserved.

The nighthawks were taking a gamble, hoping to sell their booty to unscrupulous buyers rather than going through official channels. They must have done this sort of thing before because they had the contacts.

But this world is a small one. Soon rumours spread of a major find in north Herefordshire. The rumours reached the ears of Peter Reavill, finds liaison officer for Herefordshire. It did not take long for him to attach names to the rumour. He found contact details through a detectorist society but, when he emailed them for more information, they denied any knowledge of a major find. Suspicions aroused, Reavill contacted West Mercia Police.

The police interviewed the two men and looked at their mobile phones. Although the incriminating photos had been deleted, this did not prevent

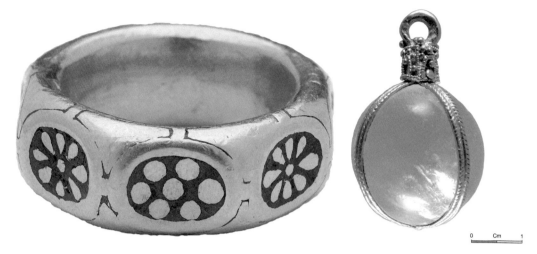

Above left: Finger ring. (Hereford Museum Resource Centre)

Above right: Crystal pendant. (Hereford Museum Resource Centre)

Below: Alfred/Coenwulf coin. (Hereford Museum Resource Centre)

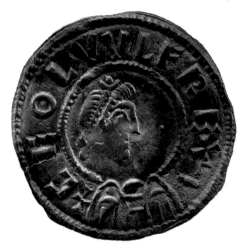

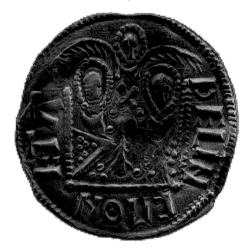

technicians discovering pictures of coins and other shiny objects still retrievable on the devices if you knew how to look.

The two men were sent for trial and, in November 2019, were convicted of failing to declare the finds. Two other accomplices were convicted of conspiracy. Although artefacts worth three quarters of a million pounds were recovered, from the photos archaeologists estimated that only 10 per cent of the hoard has been found, the true value of the whole thing being £12 million. The two men refused to cooperate in finding the missing treasure, either to protect the money they had managed to squirrel away or it had been sold to the sort of buyer who

does not take kindly to having the police asking questions about their antique collection. Instead of becoming rich men they are suffering lengthy prison terms and are likely to be watched closely by the police when they are freed.

Who deposited the hoard? Before banks existed or were fully trusted burying treasure in troubled times was a common way of protecting it, either in the hope of returning when times were quieter or as an offering to the gods. Although the detectorists refused to disclose the location, clever detective work by archaeologists pinpointed an area of wetland near two springs, just off an ancient crossroads – an ideal burying ground. Experts determined that it was buried sometime between the summer of 878 CE and the autumn of 879. The Great Viking Army had recently ravaged the land but, in this period, were in retreat after a successful fight-back by king Alfred. (Historians now think of the term Viking as a job description rather than a racial identifier; someone who goes out to seek his fortune rather than stay home farming.) The treasure was buried in the expectation that when the tide turned in the Viking's favour it could be reclaimed. But that was not to be. Bodies found at Sutton Walls near Marden were assumed to be those of King Ethelbert's bodyguard killed by Offa (see above). It is now thought that they might be Viking casualties from this period. Things became so bad that the army's leader, Guthrum, was forced to sue for peace and convert to Christianity.

Once the site was discovered archaeologists did a thorough search (so there is no point in other rogue detectorists making a visit). Nothing further was found and what has been recovered of the hoard is now in the possession of the British Museum. It is hoped that, when the new library and museum is re-located to it can be displayed there.

The curse of the hoard continues. While I was writing this book (April 2023) two more men were convicted of handling and conspiring to sell coins stolen from the hoard and the judge warned them that they could expect lengthy prison terms. Only twenty-nine of an estimated 300 coins have been recovered. To give an idea of what has been lost, some of the coins depict both Alfred and Ceonwulf, King of Mercia. Clearly they formed a close alliance to defeat the Vikings. But Ceonwulf has been written out of the historical records, written by Alfred's clerks. There he is described as a minor noble and puppet of the Vikings. Now it appears that he was much more important than that before mysteriously disappearing from the chronicles. Alfred might have been Great, but he did not like sharing...

As four men fester in prison, readers of JRR Tolkien will recall that the lure of gold is a dangerous thing.

Vikings were formidable warriors but never wore horned helmets. (Gioele Fazzari from Pixabay)

20. THE ECOCIDE OF THE WYE

The Spirit of the Wye. (Herefordshire Wildlife Trust – Recovering the Wye)

The River Wye was held sacred by our ancestors on account of its beauty and life-giving water. It was one of the great salmon rivers of the country as well as supporting a wide variety of biodiversity, home to otters and dragonflies, kingfishers and herons and a myriad other creatures. Sadly, all this is in danger. Severe pollution has wreaked havoc, so much so that conservationists are now arguing as to whether the river is close to dying or already dead. When something sacred is lost we lose an important part of our soul.

After the Second World War, people hoped for a better life after the privations of the war. One of the ways this could be achieved was cheaper meat. Chicken used to be a luxury, but new farming practices changed that. Out went the sight of flocks of the birds grubbing for food in farmyards and in came indoor housing, where they could be confined in larger stocking density. This culminated in birds that could be raised from hatching to dispatching in as little as six weeks, in that time growing so fat that their legs could not support their weight, and cheaply producing battery eggs.

The Wye in happier days. (David Phelps)

The Welsh Marches were considered ideal territory by the chicken producers for building their factory farms. Neither Powys nor Herefordshire councils looked at the cumulative total of farms being built in their area, treating each planning application individually. It was left to organizations like the Campaign to Protect Rural England and its Welsh equivalent to highlight the danger. By the time the councils realised they had a problem and discovered how many chicken farms they had allowed in the Wye catchment area it was almost too late.

The problem is that chickens don't just produce meat, they also produce effluent, which is high in phosphates and nitrogen. Inevitably much of this ends up as run-off into watercourses. This results in algal bloom, the algae loving the nutrient-rich waste, so that they can outcompete other water plants and starve the river of oxygen. It is estimated that 90 per cent of water crocus have been destroyed, with the knock-on effect on biodiversity. The number of freshwater shrimps, who are a common food source for many other creatures, has plummeted. Low water levels caused by climate change and over-extraction exacerbate the problem. Shamefully the chicken producers knew there was a problem back in the 1980s from a similar situation in the United States but, following the cigarette manufacturers' playbook, denied there was an issue until very recently.

Above: Algal bloom. (Mike Dunsbee, Friends of the Lower Wye)

Below: Algal bloom. (Mike Dunsbee, Friends of the Lower Wye)

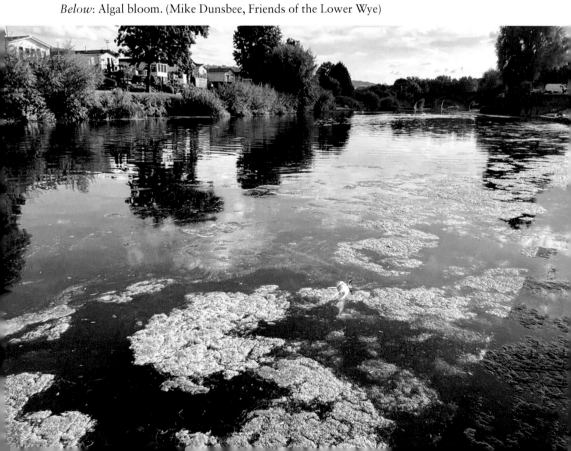

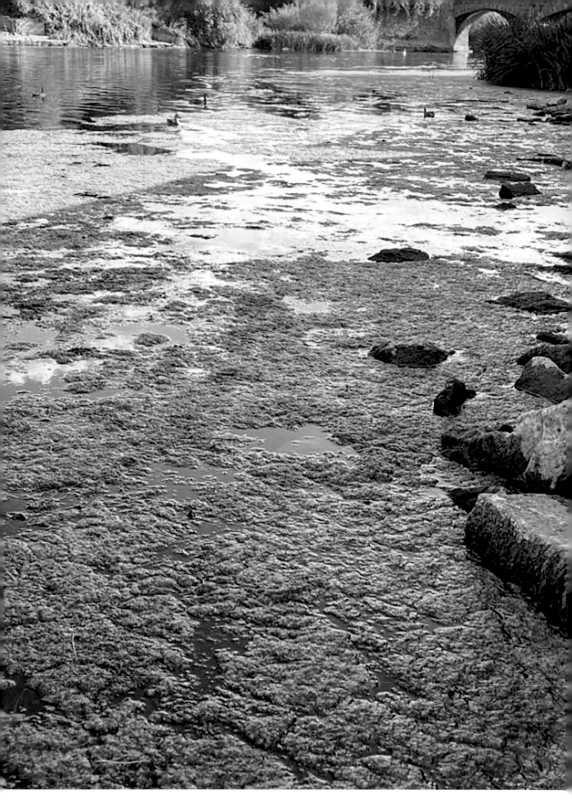

Algal bloom. (Mike Dunsbee, Friends of the Lower Wye)

Algal bloom. (Mike Dunsbee, Friends of the Lower Wye)

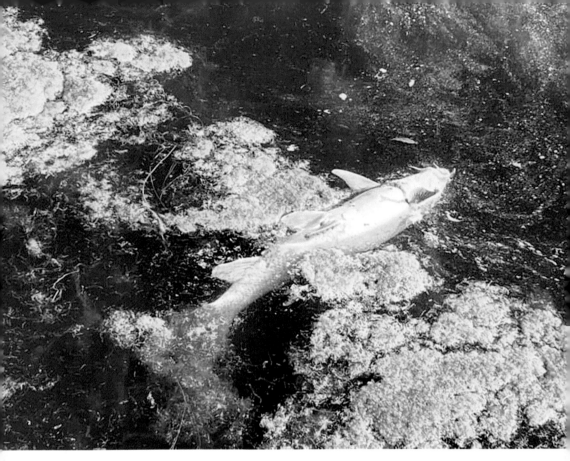

The effect of algal bloom. (Mike Dunsbee, Friends of the Lower Wye)

It is not just chicken farming that is to blame. Herefordshire used to be a largely pastoral county; its rolling hills and good grassland make it ideal for this. But changing agricultural finances have led to the browning of Herefordshire as more land is devoted to crops such as potatoes and maize. Both need large amounts of water and large amounts of nitrogen and phosphate-rich fertilisers, much of which ends up in the rivers. Extensive pesticide application is also needed to eradicate pests – or wildlife as they were once known. This not only kills off the insects but also leaches into the streams and rivers, destroying creatures there.

Can anything be done? Citizen scientists are now monitoring the dire straits the Wye is in, where cash-strapped official bodies have failed to do so. Now we know the problem we will have to decide if we want cheap meat or honour sacred beauty of the river on which our future depends.

Above: The browning of Herefordshire – maize. (David Phelps)

Below: The browning of Herefordshire – potatoes. (David Phelps)

Above: The browning of Herefordshire – industrial fruit production. (David Phelps)

Below: The Goddess of the Wye will rise again! (Mike Dunsbee, Friends of the Lower Wye)

BIBLIOGRAPHY

Clarke, Emily, *Who Killed Simon Dale?* (Logaston Press, 1993)
Heins, Nigel, *Flashback II* (*Hereford Times*, no date)
Leather, Ella Mary, *Folk-Lore of Herefordshire* (Jakeman and Carver, 1912)
Shakesheff, Timothy, *Rural Conflict, Crime and Protest* (The Boydell Press, 2003)
Sly, Nicola, *Herefordshire Murders* (The History Press, 2010)
Weaver, Phillip, *A Dictionary of Herefordshire Biography* (Logaston Press, 2015)

ACKNOWLEDGEMENTS

My thanks to Nick Grant of Amberley Publishing for commissioning the book and to him and his colleagues for their usual high-quality production. I am grateful to Jennifer Dumbleton, Hereford Cathedral librarian, and Abby Jones, Cathedral Marketing Manager, for discussions about St Ethelbert and permission to use the beautiful icons that form the St Ethelbert shrine. Also the staff of the Judges' Lodging, Presteigne, for their help with the Mary Morgan tragedy. Alison Newsam for information on the Berrington Hall murder and Tim Cooke and his niece Julieanne for letting me know about the Herefordshire Commotion. I would never have found the grave of Phillip Ballard without the help of the current residents of the Knoll, Tupsley, and the help provided by the churchwardens of Cusop church was invaluable. John Wilson, editor of the *Hereford Times*, for archive photographs from his paper and Judith Stevenson of the Hereford Museum Resource Centre for illustrations of the Herefordshire Hoard. Frances Weeks of Herefordshire Wildlife Trust and Mike Dunsbee of the Friends of the Lower Wye were also immensely kind in allowing me to use the hard-hitting photos of the pollution of the Wye.

Above all my gratitude to my partner, Valerie Dean, my first reader, co-driver and photographer, without whose care this book would never have been completed.